# IMAGES
# *of America*

# WESTON

*To my husband, Tom Failla, who shares my love for Weston's rich history and distinctive natural beauty.*

IMAGES
of America

# WESTON

Kathleen Saluk Failla

ARCADIA

First printed in 2003.

Published by Arcadia Publishing,
an imprint of Tempus Publishing Inc.
2A Cumberland Street
Charleston, SC 29401

Printed in Great Britain.

Library of Congress Catalog Card Number: 2003106108

For all general information, contact Arcadia Publishing:
Telephone 843-853-2070
Fax 843-853-0044
E-mail sales@arcadiapublishing.com

For customer service and orders:
Toll-free 1-888-313-2665

Visit us on the Internet at www.arcadiapublishing.com.

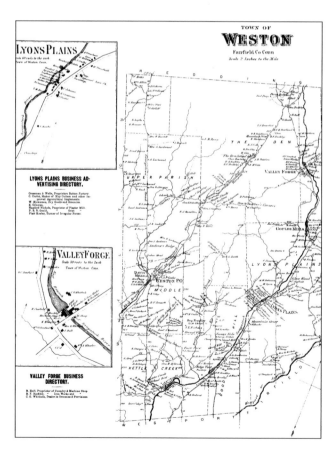

This map of Weston from the *Atlas of Fairfield County, Connecticut*, was compiled by F.W. Beers and published in 1867.

# CONTENTS

# ACKNOWLEDGMENTS

Many people have helped make this book possible and I would like to thank them for their contributions.

First, my thanks to the Weston Board of Selectmen—Woody Bliss, Glen Major, and Richard Miller—for endorsing the project's concept and issuing an official resolution asking citizens to assist. The Weston Historical Society also deserves many thanks. In particular, I would like to thank the society's president, Paul Deysenroth, and archivist, Mary Ann Barr, for their assistance in researching the book. Many photographs that appear in this book are from the society's collection.

Weston's first pictorial history would not have been complete without the contributions of private citizens and organizations that loaned photographs and spent time providing insights into Weston's history. They include Ralph Bloom, retired Norwalk Museum curator; Donna Edwards Brinckerhoff; Ernest and Judy Albin Jr.; Allen Brings and Genevieve Chinn; Charles and Lisa Daugherty; Msgr. Nicholas V. Grieco and Frank Michels of St. Francis Roman Catholic Church; George and Linda Guidera; Louise Messex; Fred Moore and Joseph Spetly of the Weston Volunteer Fire Department; Barbara Narendra, Yale University's curator of the Peabody Museum meteorite collection; Charles Niewenhous; Steve Patton and Sally Harold of the Nature Conservancy's Devil's Den Preserve; Christopher Plummer; Helen Rosendahl; Morton Schindel; Frederick Schneider; Julia Studwell; and Barbara Wagner.

Standard local references provided an abundance of information. These include *Weston: The Forging of a Connecticut Town* by Thomas J. Farnham, *God With Us: The Parish of Emmanuel Church Weston* by Ruth L. Hickcox, the Weston Historical Society's *The Chronicle Quarterly*, *Weston Forum*, *Westport Town Crier*, the *Westporter-Herald*, the *Bridgeport Post*, Weston's *Town Plan of Conservation and Development 2000*, and the *Weston Environmental Resources Manual*.

# INTRODUCTION

The history of Weston is not tied to Revolutionary War battles, famous statesmen, or national landmarks. Yet all that happened to America happened here.

Weston was officially incorporated as a town in 1787, but the events that influenced its formation began much earlier. In 1635, Roger Ludlow, an Englishman and deputy governor of the Massachusetts Bay Colony, led a small band of settlers to Connecticut. He came to play a significant role in the life of Connecticut and founded Fairfield, Weston's predecessor town.

Weston was so named because of its northwest location relative to its mother town of Fairfield. The name is also a throwback to Colonial Massachusetts and, earlier, to England. Present-day Weston still bears some resemblance to the isolated wilderness of forests, streams, and rocky slopes that Native Americans and English settlers trod. The Native Americans treasured Weston's forests, where they hunted for food. Their nomadic route from Long Island Sound inland in winter brought them to Weston. Here, they found shelter in caves beneath rocky ledges and in deep ravines, which are today preserved on thousands of acres of open space lands by the Nature Conservancy, the Aspetuck Land Trust, and the town of Weston.

Early settlement was spurred by Fairfield's division of communal land into long lots, beginning in 1671. Although boundaries were disputed until 1760, after an initial survey in 1726, families could be reasonably sure that the land they cleared for farming belonged to them. This propelled Weston's settlement as property lines were drawn. The names of these early settlers, whose property extended 12 miles north from Fairfield's "mile common" at Long Lots Road, are intertwined with Weston's history. Their names included Banks, Burr, Gilbert, Wakeman, Rowland, Osborn, Bradley, Coley, Sherwood, Sturges, Lockwood, Beers, and Smith. These early settlers were called "outlivers" because they settled the back country. Most were younger sons. Although they inherited a parcel of their fathers' farms, the inheritance was a mixed blessing. Located far from village and family, the soil on the parcels was poor and travel was difficult. Joined by poor farmers, hunters, and trappers who could not afford more fertile land along the coast, this subsistence community was as enterprising as it was hardy. The thin layer of glacial till was a challenge to farm. Weston's moist, cool climate, not much different from today, helped determine the crops that would be grown—onions, potatoes, corn, oats, rye, and hay. The availability of water power from rivers and the abundance of natural resources including forests, fish and game, iron, lead, garnet, stone, sand, and gravel offered opportunities to enhance their incomes.

Although industries, such as gristmills and sawmills, existed before the American

Revolution, it was not until the 19th century that Weston developed factories and iron foundries, swelling the population in a series of vibrant villages that included Valley Forge, submerged beneath the Saugatuck Reservoir since 1941.

Before Cobb's Mill Inn was a restaurant, it was a gristmill powered by a dam on the Saugatuck River. Weston even had a toy factory, and the building at Aspetuck Corners still stands. The G.W. Bradley Company's axes and tools were sold worldwide, and it was the town's largest employer until a fire destroyed it in 1911. In the next two decades, the town's population fell below 1,000.

The town's initial step toward independence from Fairfield occurred in 1757, when the outlivers formed their own ecclesiastical society, the Norfield Society. Modeled after an English parish, Norfield was both religious and political. It had the power to tax and build schools, became the foundation of today's Norfield Congregational Church, and gave that part of North Fairfield, which would eventually be incorporated as Weston, its own identity. The first meetinghouse was built near the intersection of Norfield and Old Hyde Roads. During the American Revolution, Rev. Samuel Sherwood, Norfield's first minister, whipped up patriotism among his small congregation with his influential sermons. On his mother's side, Sherwood was related to Aaron Burr. By 1776, Norfield's population had reached 1,000. More than 50 men fought in battles, some at Yorktown. Fanton Beers spent a winter with George Washington at Valley Forge. Because of the town's poor roads, the advancing British did not travel directly through the center of Weston. They skirted the town and their direct route to Danbury is not known, although some think they took the cross highway, known today at Lyons Plain, north to Redding, Ridgefield, and Danbury. The closest battles were at Ridgefield and Westport, where Norfield militia fought Gen. William Tryon's troops and gave inspiration to the Minuteman statue at Westport's Compo Beach.

In October 1787, Weston was incorporated as a town. The Connecticut General Assembly, over Fairfield's objections, finally approved the local petition. With the town's incorporation, the church's authority declined. The town meeting became a focus for political activity.

Weston's town meeting form of government is still in force today. We see it in practice annually as voters gather to approve the town budget. Like their forbearers, more than 200 citizen volunteers today are actively involved in town government. Their contributions of time and talent enable the town to conserve its operating budgets.

After World War II, Weston's population grew to almost 2,000 by 1950. The improvement in highways like the Merritt Parkway and Route 57 attracted homebuyers. They discovered the tranquility and rustic charm that celebrities, artists, musicians, and writers found in the 1920s when a Weston-Westport arts community began to flourish. Captivated by the town's natural beauty and volunteer spirit, organizations like the Weston Volunteer Fire Department (1931) were formed. Some residents, like *New Yorker* cartoonist Wood Cowan, served in public office. Others, like Catherine Ordway, who played a prominent role in the U.S. conservation and open space movement, got their start here.

Today, Weston's beautiful, natural landscape and fine school system attract many families, and the population is just over 10,000.

# One

# THE EARLY DAYS

*If you look at any map, particularly the old maps, you will see these parallel roads.*
*They were laid out where your shadow falls at eleven o'clock.*
—Mrs. Webb Waldron, 1970.

When early Weston was laid out in long lots, property was distributed according to a family's need—the more children, the larger the land allotment. Likewise, when roads were surveyed, early transportation planners also took what they considered a practical approach. Using an ancient principle, they laid out routes according to the principle of "eleven o'clock roads." So as the old-time surveyor's shadow fell at eleven o'clock, the town's road system began to take shape, creating a lasting influence on the town's orientation of north-south roads.

Early planners called the north-south routes "upright highways," and east-west roads were called "cross highways," such as Godfrey and Lyons Plain Roads. Looking at a modern map of major town and state roads, the original grid system established in 1725 is still evident. Instead of following old deer and elk paths and Indian trails, settlers forged new roads, which old timers say might not have been the best approach, given all the town money that went into straightening out those curves and smoothing the bumps.

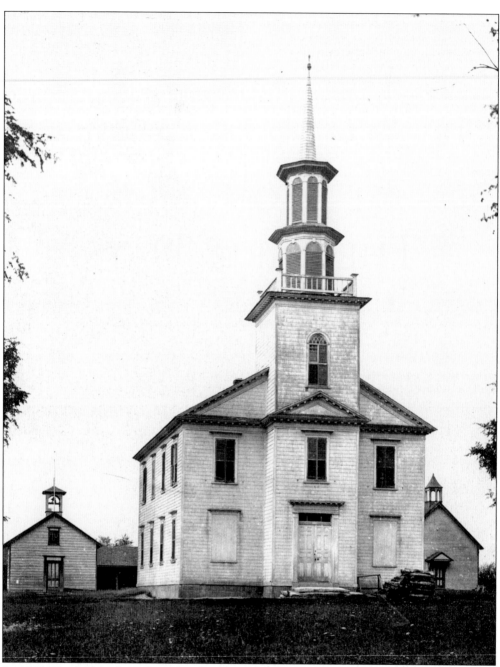

In 1758, Norfield built its first church on Kettle Creek Road, south of Heritage Lane. The building was never completed. In 1784, the timbers were recycled to construct a new church at the corner of Norfield and Old Hyde Roads. This served the parish for 46 years until it was rebuilt at its current location. This photograph, taken in 1910, illustrates how the church was the center of town activity for many years. Notice Weston's middle school, a one-room schoolhouse, located behind the church on the left. To the right of the church is the old town hall. Social life revolved around the church—even for nonmembers. The annual Norfield Congregational Church Fair, started at the end of the 19th century, continues to draw fairgoers from far and wide.

The Coleys were a prominent Weston family. They were farmers, entrepreneurs, factory owners, and first selectmen. Pictured here c. 1860 is Harriet Bradley Banks Coley, born in 1831 at the Banks Tavern on Lyons Plain Road. Harriet was the daughter of Samuel Banks, the wife of Frederick Coley, and the mother-in-law of first selectman James A. Smith (1893–1902).

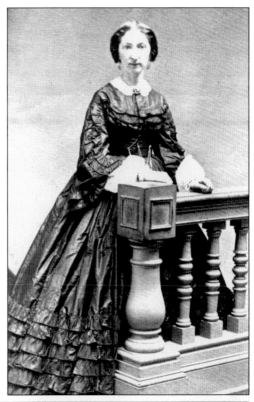

Newcomers enchanted by Weston's small-town New England setting strive to preserve it.

The David L. Coley (1715–1802) homestead still stands on River Road. Photographed in 1909, this view looks northeast. River Road curves north on the left. The oak tree is gone. Slave quarters on the east side of the house were removed. At one time, the farm and mill complex were one of the largest in town.

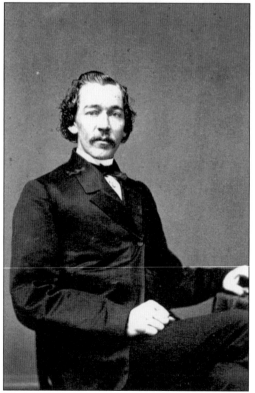

This *c.* 1860 photograph of Jessie Nichols is from an old album George Guidera discovered in the Samuel Banks house, 227 Lyons Plain Road, where he lives. The Nichols family was made up of influential mill owners and farmers. After Easton's separation from Weston in 1845, voters at the next Weston town meeting elected three selectmen, and one was Hanford Nichols. He played a major role in the establishment of Weston's second church, Emmanuel Episcopal.

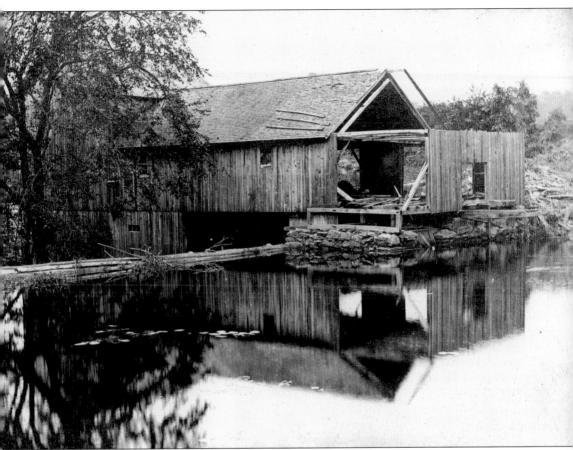

The old Davis Grist and Sawmill, later Cobb's Mill Inn, harnessed its power from the west branch of the Saugatuck River. Farmers brought their corn and rye for grinding into flour. Trees were hauled there to be cut into lumber for local construction. At one time, a general store and post office operated on site. The mill is thought to date to the 18th century. In 1934, Alice Delamar and Jacques De Wolfe purchased the property, which, in the late 1920s, attracted well-known artists, actors, and writers as overnight guests. They converted the inn into an expensive eating and drinking establishment, far beyond the means of local residents. The restaurant continues its fine tradition today. For diners, the sight and sound of water rushing over the dam is as appealing as it was centuries ago.

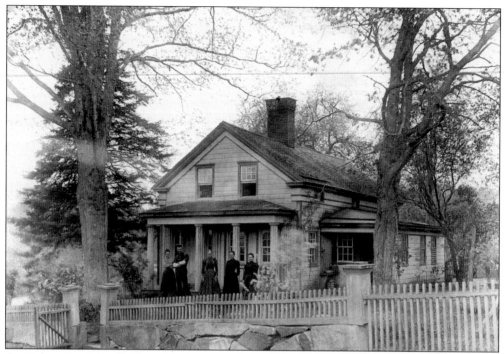

On Calvin Road, the Scribner family enjoys the early spring breeze that wafts through the open windows on the second floor.

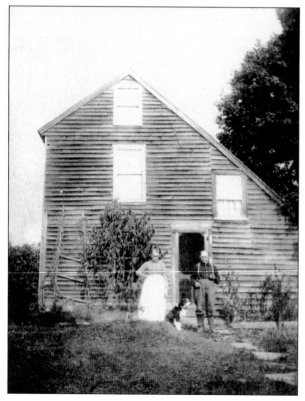

Bradley White and his wife stand outside their home on Davis Hill Road.

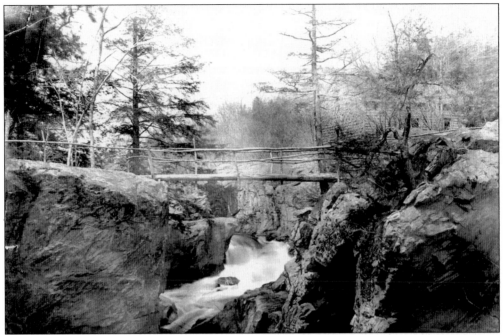

A rustic footbridge across the Saugatuck River at Devil's Glen was used by employees of Gould's Mill. One of the mill's buildings is seen on river's east bank, adjacent to Valley Forge Road.

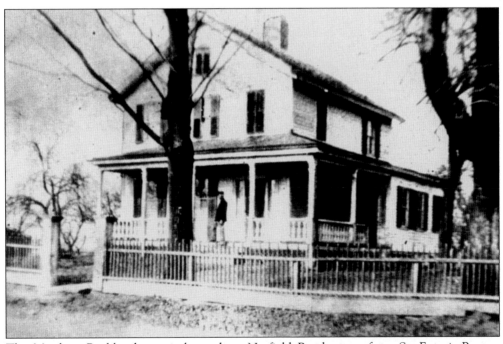

The Matthew Buckley home is located on Norfield Road across from St. Francis Roman Catholic Church. The house has been modified and the porch removed.

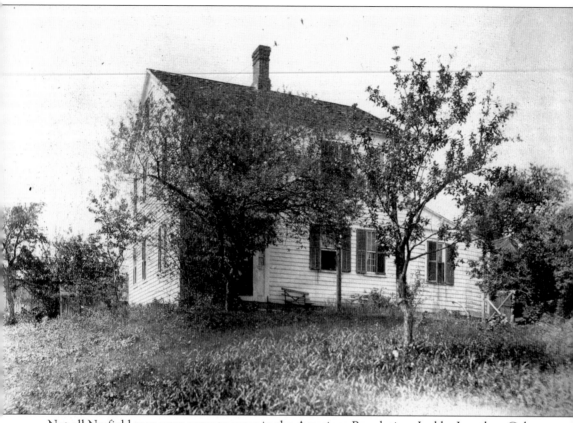

Not all Norfield men were eager to serve in the American Revolution. Led by Jonathan Coley, some draftees decided to party instead of reporting for duty. During a gathering at the John Andrews home, 38 Kettle Creek Road, they were dispersed by local militia, who surrounded the house. Coley managed to elude his captors and, later, avoided the draft by hiring a substitute. The photograph was taken *c.* 1912.

The Norfield Congregational Church's early parsonage stood at the corner of Norfield and Old Hyde Roads. When the church was rebuilt at its current location in 1830, the parsonage also moved. This photograph was taken in the 1860s after the parsonage had been converted to a private residence.

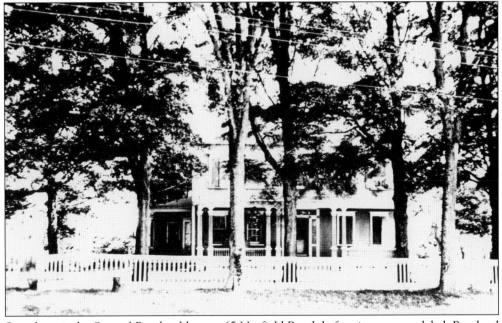

Seen here is the Samuel Rowland house, 65 Norfield Road, before it was remodeled. Rowland donated the land on which Norfield Congregational Church built their second church at the corner of Norfield and Old Hyde Roads.

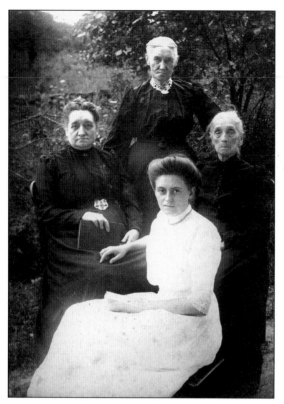

This photograph of four generations of Weston women was taken on August 4, 1911. Pictured are Georgia Lyon, age 24, along with her great-grandmother Rachel Banks, 93, her grandmother Mary Patchen, 75, and her mother Ida Lyon, 53. Georgia lived at 124 Old Redding Road until she married George Eichinger of Wilton; they moved next door to a farmhouse where their daughter, Louise Messex, resides today.

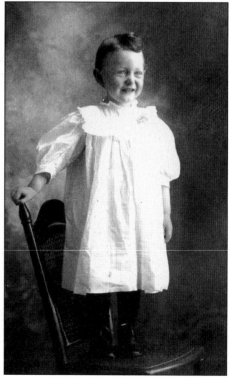

Irving Patchen was two or three years old when this photograph was taken in 1904. He grew up to become a master carpenter and lived at 265 Lyons Plain Road. His grandfather built the first steeple on Emmanuel Church. In 1931, Patchen joined with others to establish the Weston Volunteer Fire Department and put his home up to guarantee a loan for firefighting equipment.

Jessie Kellogg Patchen is pictured here in August 1892.

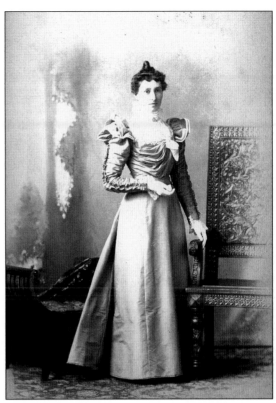

Clifford Patchen, father of Irving, is pictured here in August 1892. He distinguished himself as master carpenter of major barn projects, such as the Bedford barn in Greens Farms, the site where Stauffer Chemical located its headquarters in the 1970s.

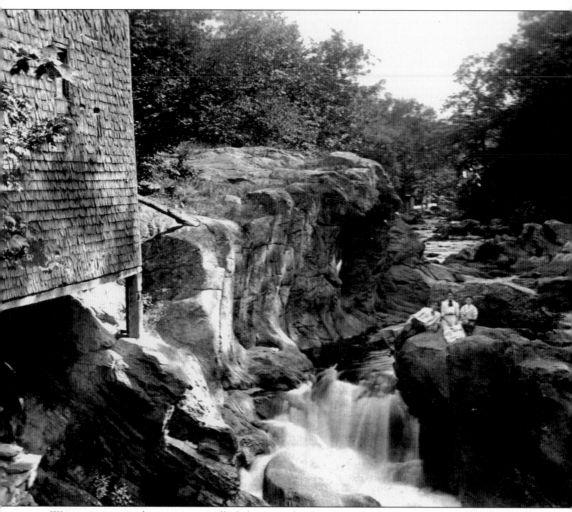

Weston rivers and streams propelled the growth of early industry, such as Gould's Mill, on the right, in Valley Forge. They were also an allure for people seeking beauty and peace.

This was one of the tollhouses on the Norwalk and Newtown Turnpike, a private thoroughfare. Entrepreneurs started turnpike companies to build and maintain better roads. Weston's most famous toll collector was Henry Hamilton, a cobbler, who bought the house at 291 Newtown Turnpike in 1840 and built this tollhouse as a cobbler's shop and tollbooth. Newtown Turnpike became a public road in 1851.

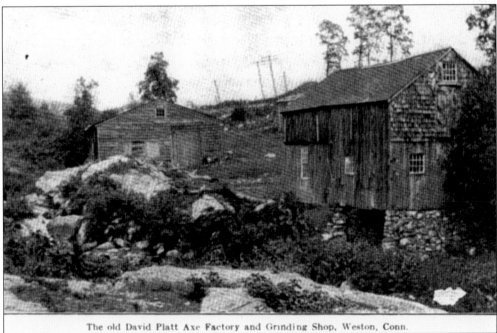

The old David Platt Axe Factory and Grinding Shop, Weston, Conn.

The old David Platt Axe Factory and Grinding Shop, located on Newtown Turnpike, made tool handles. It is an example of industry in Weston that dates to the late 17th and early 18th centuries.

21

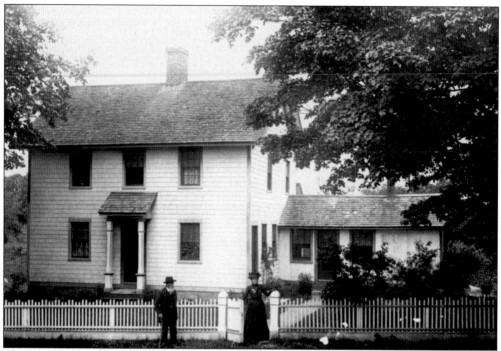

The Simeon Fanton house, 98 Old Redding Road, was built in 1815.

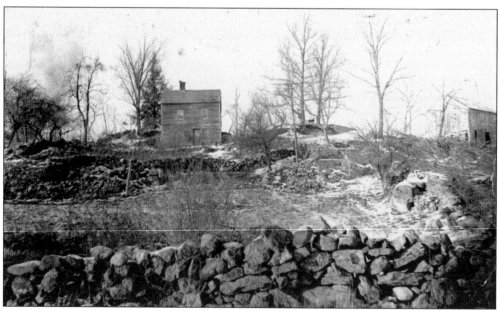

The Adkinson Hilton home, 10 Old Weston Road, was built in 1780. This photograph was taken in 1884. Hilton was a sergeant during the American Revolution. In 1938, MacLennon Farrell bought the home.

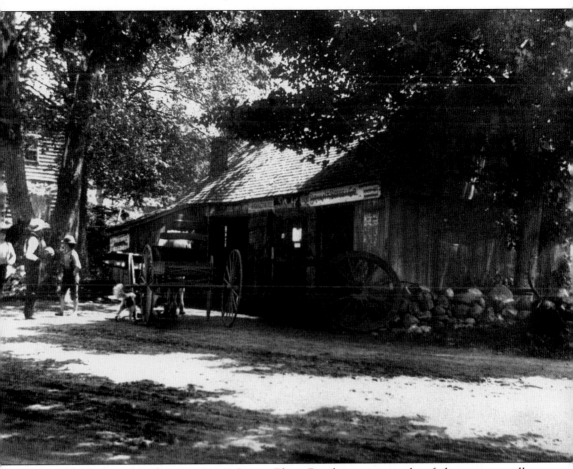

The old blacksmith's shop on upper Lyons Plain Road is an example of the many small businesses that developed to serve local needs. Many craftsmen were also farmers. This shop stood near the end of Lyons Plain Road, where it intersects with Kellogg Hill Road.

Looking north from Old Redding Road toward Trout Brook Valley, this photograph was taken of a barn and field across from 138 Old Redding Road. The field is now densely wooded, but at one time it was part of a small dairy farm.

Charles Lyon is pictured in his field in the early 1900s. A strapping six foot three inches in height, he was a hard-working farmer who lived at 124 Old Redding Road. His granddaughter, Louise Messex, said she took first place at school races because she learned early she had to run to match her grandfather's long strides. His house survives, and the open fields are now woodlands.

Built in the late 1870s, this is the childhood home of Louise Messex at 138 Old Redding Road.

Louise Messex, age 3, is in the parlor of her home at 138 Old Redding Road with her grandmother, Ida Lyon. The parlor today looks remarkably similar. Louise attended a series of one-room schoolhouses, the first of which was Lyons Plain School, also known as Valley Forge School. When the school burned down, she went to Goodhill Road School and later graduated from Norwalk High School.

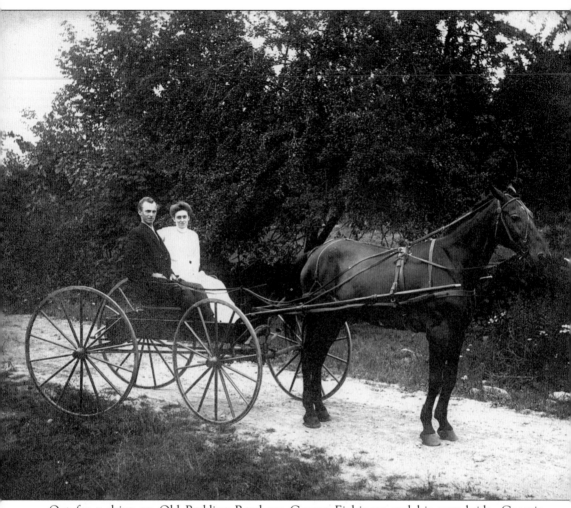

Out for a drive on Old Redding Road are George Eichinger and his new bride, Georgia Lyon Eichinger.

A diminutive Louise Messex is almost swallowed up by her sunbonnet as she poses at the side entrance to her grandfather's house at 124 Old Redding Road. Note the early farm landscaping around the house.

In this c. 1900 photograph is Mabel Kellogg Patchen, age 10 months.

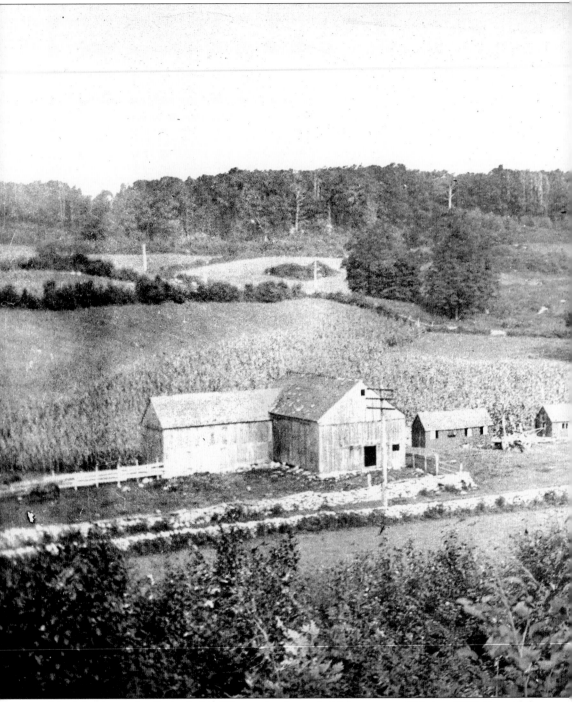

The Morehouse family settled in Weston in the early 18th century. This is a 1910 view of the family's farm built by Ebenezer Morehouse on Newton Turnpike. The view looks west from atop Hill Crest. Land developed for the Blue Spruce Circle subdivision in the late 1950s is seen behind the house and barns to the left. On the right is land donated for public purposes by the late Minerva Heady, a descendant of the original Morehouses. In front of the picket fence runs

Newtown Turnpike, then a narrow dirt road. At the top in the distance are trees that were forested for lumber. The Morehouses also grew tobacco, onions, potatoes, hay, and corn. Ernest Albin Jr., a descendant, saved the farmhouse from the wrecker's ball and moved it across the street to 479 Newtown Turnpike, where he now lives.

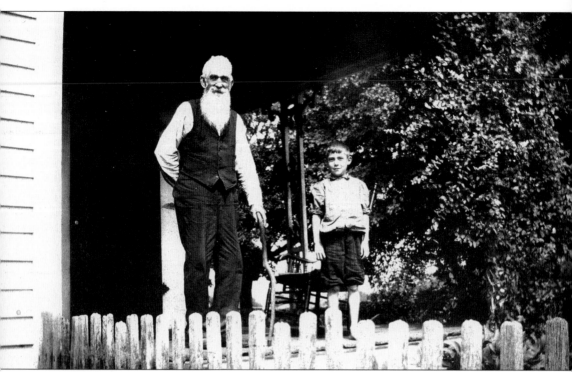

"Eight and Eighty" was the title Lena Hill Albin gave this photograph taken at the Morehouse home on Newtown Turnpike in 1910. Ebenezer Morehouse, left, who built the home with money earned as a young man in California's Gold Rush, poses with his great-nephew, Madison C. Morehouse. Holding a walking stick, Ebenezer is smiling, while Madison, barefoot, looks ready for play.

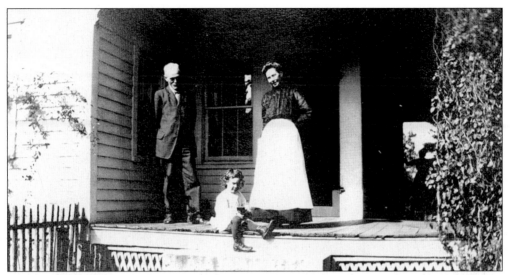

Charles Morehouse, left, poses on the side porch of the home built by his father, Ebenezer. With him are his nephew, Ernest Albin, and his sister, Carrie. The youngster is the father of Ernest Albin Jr.

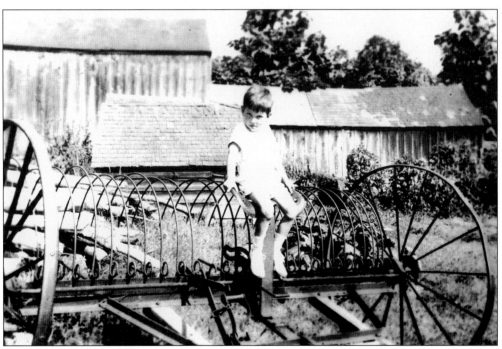

Young Ernest Albin Jr. poses on a hay rake at his family's farm on Newton Turnpike in 1936. In the 1930s, Weston was a poor farming town, the poorest in Connecticut. A few families kept up the tradition of working the land through the 1950s, but as factory and office jobs became more plentiful and transportation improved, they sought jobs outside Weston.

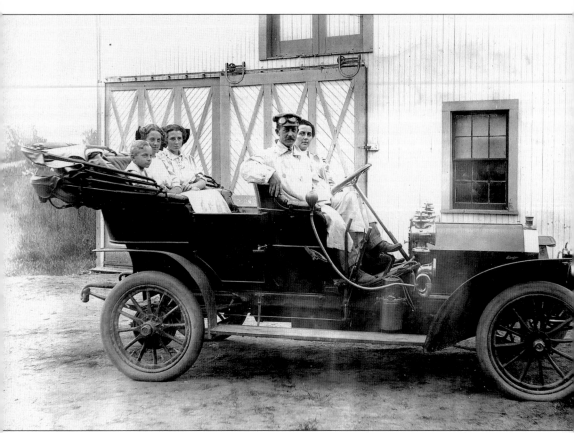

Early automobiles introduced many out-of-towners to Weston's scenic splendors. The visitors tried the patience of residents. In a front-page article on September 21, 1917, the *Westporter-Herald* reported, "Weston is Invaded by Grape Thieves." Driving through town, visitors had made it a practice of stopping to snack on wild grapes growing on private property. While some residents hastily retreated, others took stronger steps to threaten the vandals.

Weston's unpaved roads were notoriously dangerous. Many a horse and wagon, buggy, and early automobile broke an axle. The *Westporter-Herald*'s lead story for Weston on December 12, 1917, reported that mail carrier Charles Keene was thrown from his vehicle after his carriage broke an axle. The accident took place in Upper Parish, near the residence of John Fitch.

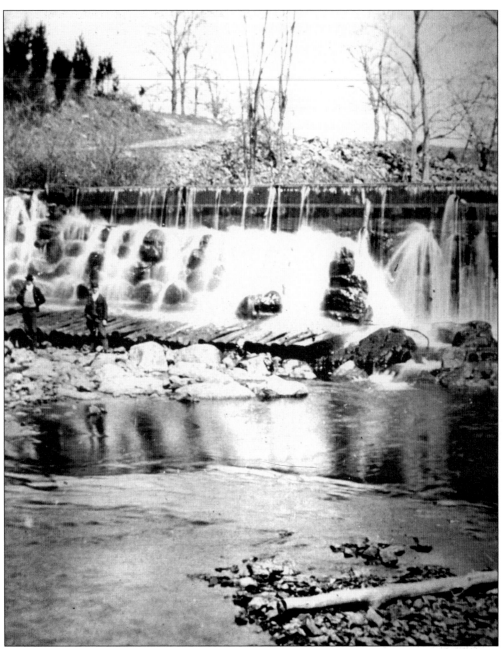

Weston's rivers and streams furnished the power necessary to operate mills and factories. The ample supply of power and forests needed to produce charcoal, another requirement of manufacturing, tended to attract aspiring manufacturers. They moved to town to establish iron forges in Valley Forge. Unlike industry today, these early businesses were helped, but also hampered, by nature. When rivers ran dry or when spring rains created a deluge and spawned ice floes, factories and mills closed down. This photograph was taken at the Bradley axe factory dam after a fire destroyed the complex in 1911.

# Two

# INDUSTRY AND FARMING

*Yankee axes, that's what they were. Designed, shaped and forged by Yankee stock. The Bradley
axe made in Weston for 100 years was the finest axe of its time and there still live many
who helped make it—the axe unsung, that went into the making of the pioneer west.*
—Greshom Warren Bradley, 1931.

Industry grew out of necessity as soon as the early settlers put down roots long enough to realize
they must manufacture all they needed—from flour ground at the gristmill to lumber and tools
to build homes and barns. Propelled by abundant water power and natural resources, Weston
developed as a small industrial center through the 18th and 19th centuries.

Weston had three primary categories of industry—cottage, charcoal-making, and factory and
mill operations, including the G.W. Bradley Edge Tool Company, the largest firm in town. On
Lyons Plain Road, farming and manufacturing went hand in hand, with small farmers subsidizing
their income working as carpenters and blacksmiths. There was a small iron industry in Valley
Forge. Onions were Weston's cash crop because they were easy to grow and could be stored in
root cellars until sold. Fred Banks and his son, Willis, marketed their popular Southport Globe
variety in Westport and from there the produce was shipped to New York City.

The industrial revolution with its steam engines and railroads brought a slow end to the small
mills and factories of Weston. Farming, too, was no longer profitable because grain, meat, and
vegetables could be shipped by rail. Remote and rugged, Weston over time lost its industrial and
commercial connections.

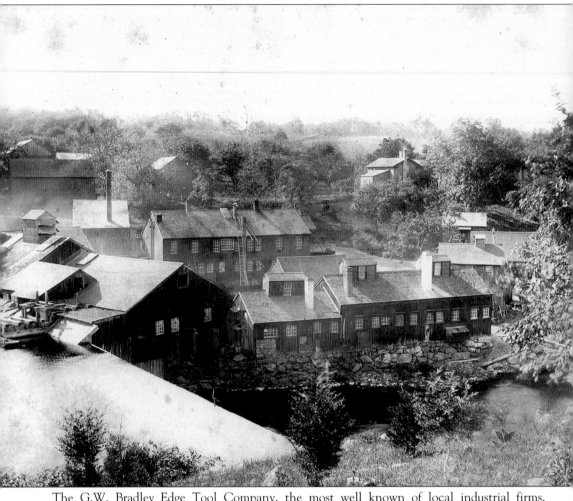

The G.W. Bradley Edge Tool Company, the most well known of local industrial firms, produced a variety of tools, axes, knives, and machetes that were sold around the world. Located on Lyons Plain Road across from White Birch Road, the factory benefited from its location on the Saugatuck River, which provided water power. Established by Gershom W. Bradley in 1843, the factory operated until fire destroyed it in 1911.

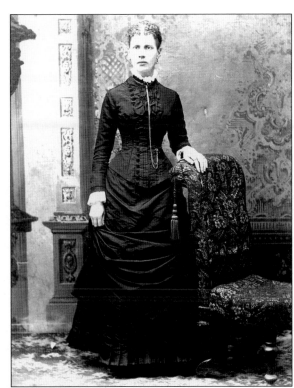

Ralph Bloom, curator of the Norwalk Museum, presented the Weston Historical Society with these undated portraits of Gershom Bradley and his wife.

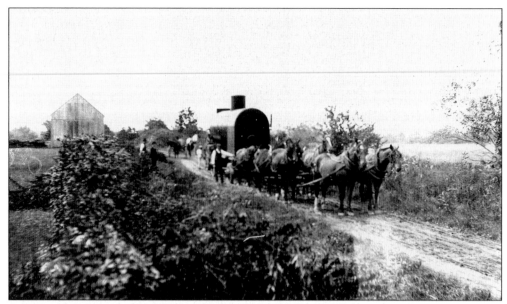

A team of horses transported the new boiler for the Bradley axe factory along Lyons Plain Road. Mule and oxen teams were used to transport all that the factory required, including Sheffield steel imported from England. Materials were delivered to the Westport docks that existed at that time on Riverside Avenue.

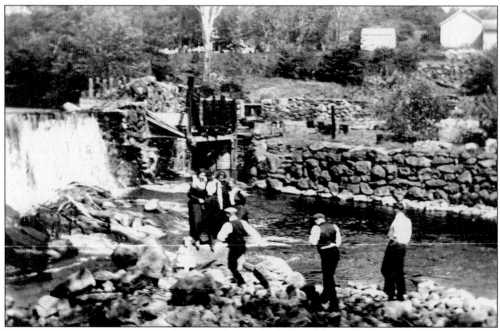

A 1911 fire destroyed the Bradley axe factory and shut down Weston's largest employer. In 1995, the area where the factory once stood on Lyons Plain Road was listed on the National Register of Historic Places as the Bradley Edge Tool Company Historic District.

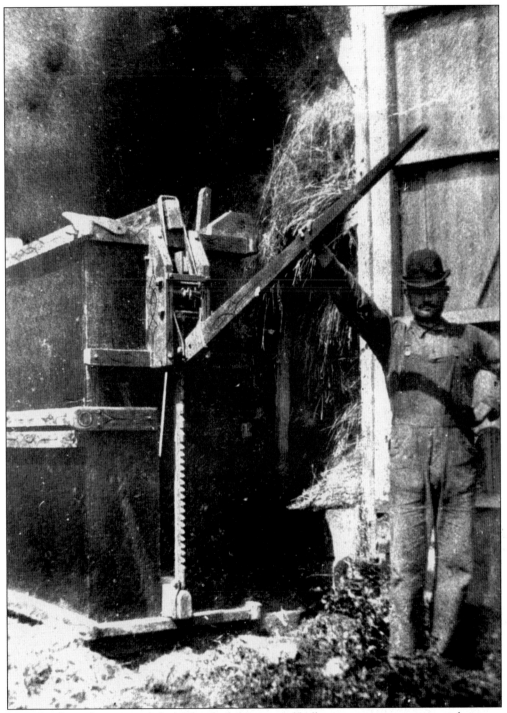

Irving Lockwood got a patent for his hay bailer. Large and bulky, it was never a commercial success.

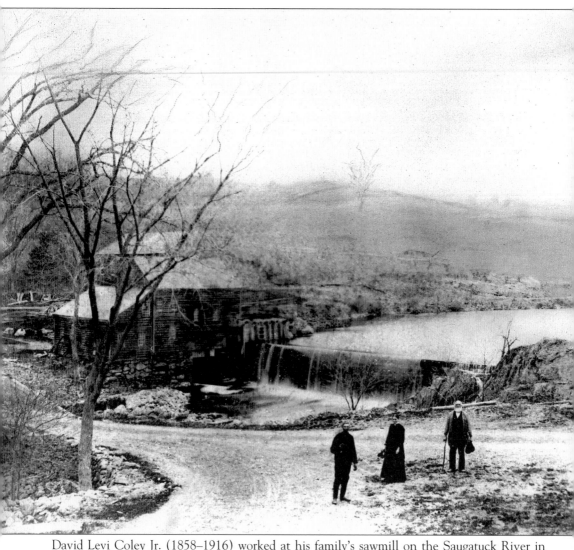

David Levi Coley Jr. (1858–1916) worked at his family's sawmill on the Saugatuck River in lower Weston before he became an entrepreneur. In the early 1880s, he opened a machine shop near the same site. The foundry produced a variety of products, including parts for firearms, stoves, and flat irons. The grinding shop was located along the river, where a waterwheel generated power. The dam created a giant mill pond that extended up the river to what is now Keene Park. Coley stands at the corner of his driveway and River Road. His home overlooks the mill.

This is a south view of the grinding shop at Coley's mill. A millstone, half hidden by a tree at the river's edge, leans against a corner of the building.

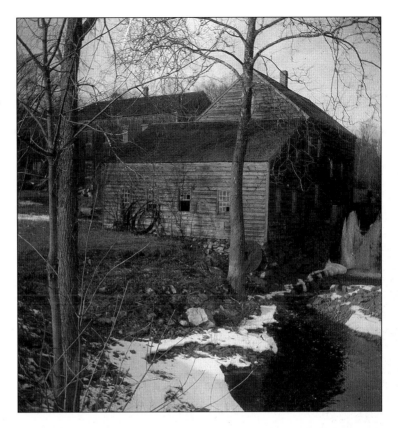

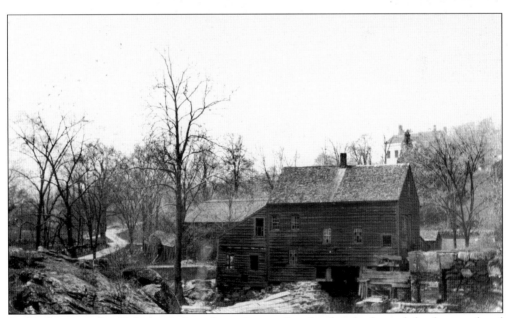

In the foreground is Coley's grinding shop, shown after the dam broke and the factory closed down. The building at the left rear is the foundry and on the extreme right is the machine shop. David Coley's house can be seen on the top of the hill, at the right.

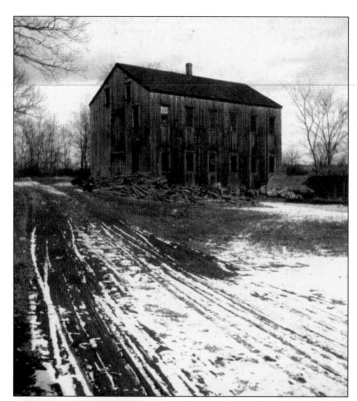

The old Coley machine shop stands out against a winter landscape *c.* 1900. In the foreground, buggy and wagon wheel tracks show Goodhill Road.

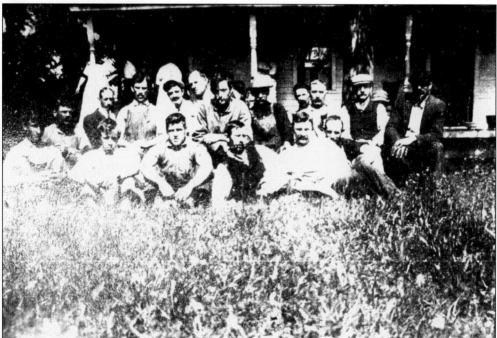

Laborers from Coley's mill enjoy a restful gathering in the late 19th century. Workers were housed in a long dormitory style building, located on Goodhill Road between the River Road extension and the Grange hall.

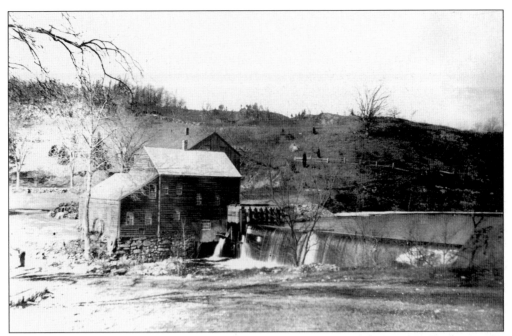

The landscape behind Coley's mill was stripped of trees that had been harvested for lumber. At the sawmill, logs were cut into lumber and moved to the storehouse, from where they were marketed.

Farmers Steve Godfrey (left) and Charles Lyon exchange a few words as Godfrey works in his field on Godfrey Road c. 1900.

The Lockwood Sawmill operated on the east side of Georgetown Road, across from Langer Lane c. 1880. Trees were harvested from the family's property in Devil's Den and cut into rough lumber, which was marketed for various uses. Railroad ties were cut from chestnut and oak and sold to the Hartford-New Haven Railroad. Lumber was cut to order for construction in new buildings and heavy oak planks were cut to make "stone boats," which farmers used to clear boulders from fields. Built from planks bolted together, a stone boat would be hitched to a team of oxen or draft horses and later tractors. Farmers would roll the boulders onto "boats" and move the rocks to the edge of the field.

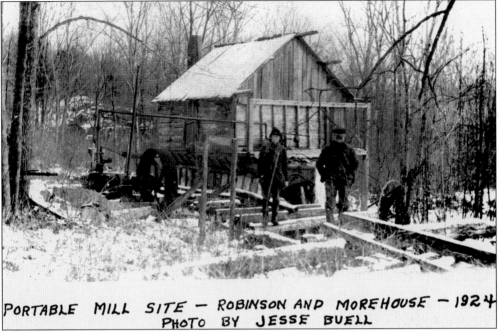

PORTABLE MILL SITE — ROBINSON AND MOREHOUSE — 1924
PHOTO BY JESSE BUELL

Yale University professor Jesse Buell photographed "Robinson and Morehouse" while surveying Devil's Den in 1924. Winthrop Perry and his wife gave 1,300 acres in Weston and Redding to Yale's school of forestry. They also gave $1,000 to survey and map it. The property was difficult to manage, so Yale returned the gift in 1930. In the photograph, the men stand next to a portable, steam-powered sawmill.

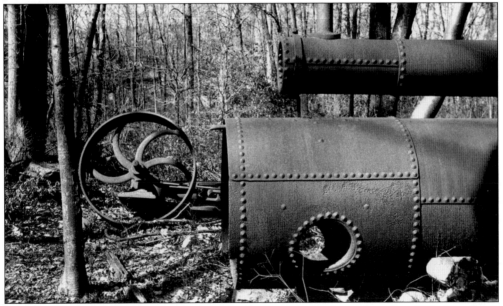

All that remains of the portable sawmill is this boiler and wheel, visible today off Godfrey Trail, north of Godfrey Pond in Devil's Den. The den's rich forest land made it a center for logging and charcoal production from the 1700s to early 1900s. Portable sawmills made it possible to mill lumber on site, rather than haul logs from the forest.

This photograph of Gould's Mill *c.* 1885 was taken before the building was destroyed by fire on August 9, 1892. The building, experts say, was built before 1800 and had a series of owners and uses. It even served as a post office. Seen here are Frank Gould (left), David B. Gould (center), and Charles Wakeman. A cider press is on the left. Rodney Merwin, a descendant of one of the building's early owners, Burton P. Merwin, said it probably was built by one of the Bradleys before 1800.

The old mill house and dam at Aspetuck Corners is a pleasant spot on a summer day. In 1798, an agricultural community flourished around the small triangle of land at Old Redding Road, Easton Road, and the Aspetuck River. This building was located on the old stagecoach road to Danbury. Helen Keller, the famous blind author and humanitarian, lived nearby. For a time, wooden toys were produced at the mill.

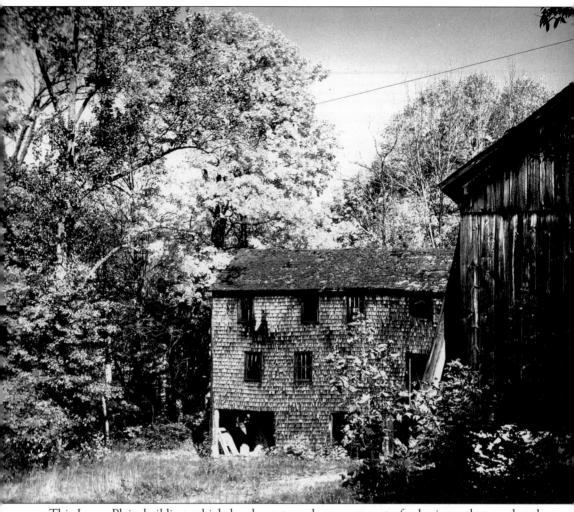

This Lyons Plain building, which has been torn down, was part of a business that produced, among other things, fence pickets.

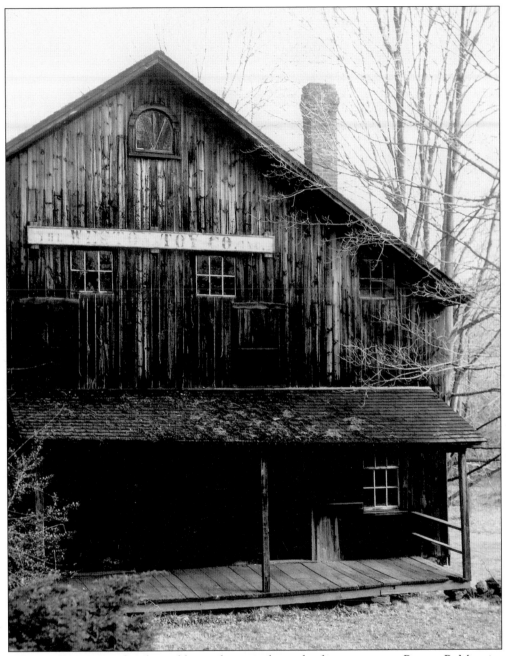

"Weston Toy Co." is barely visible on the sign above the front entrance. Burton P. Merwin, first selectman from 1915 to 1916, obtained a patent to make mechanical wooden toys. He sold the property in 1935.

The old Coley homestead, 104 Weston Road, is maintained as a museum by the Weston Historical Society. This is the main house in the 1930s. Originally, the property was part of a long lot given to Jesse Lockwood in 1758. At one time, the farm had 107 acres, but almost all were sold for development. In her will, Cleora Coley left the property to the historical society.

Looking off in the distance from atop the field at the Coley homestead in the 1930s is like looking into the past, when the farm was part of the original long lots.

The Coley barn is snow-covered in this winter scene from the 1930s. James Coley donated the barn to the Weston Historical Society in 1963. The original barn, owned by David Dimon Coley (1811–1894), was destroyed by fire in December 1882.

Behind the car is a bunkhouse, where the Coley farm hands were housed.

Father and son are posed c. 1965 in front of the stone wall that still stands on the Coley home, now a museum. Seen here are the late James B. Coley (left) and his father, the late James Sturges Coley.

In the 1960s, the Coleys still farmed at 104 Weston Road. Here, the late James B. Coley, then a teenager, tends the oxen.

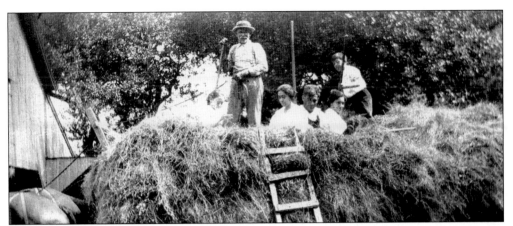

Harvesting hay was a predictable farm chore. Loaded down with hay for animal bedding, this group atop the horse-drawn wagon pauses long enough for a photograph *c.* 1918. Ahead of them lay the task of unloading it in this barn on Lyons Plain Road.

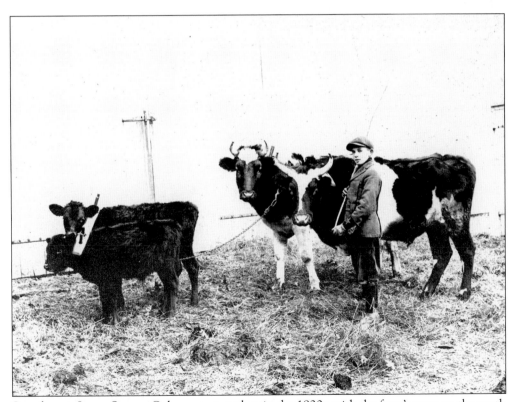

Seen here is James Sturges Coley as a young boy in the 1920s, with the farm's oxen on the south side of the barn.

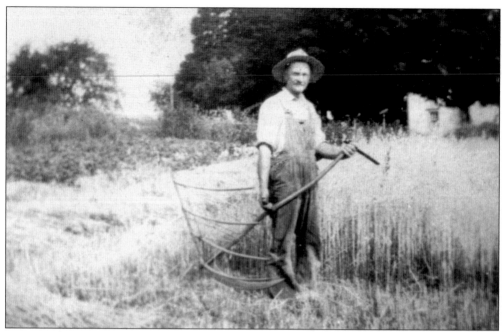

Here, the farmer uses a cradle scythe as his ancestors did to cut the hay crop. In Weston, a good field of hay could usually be harvested twice a year.

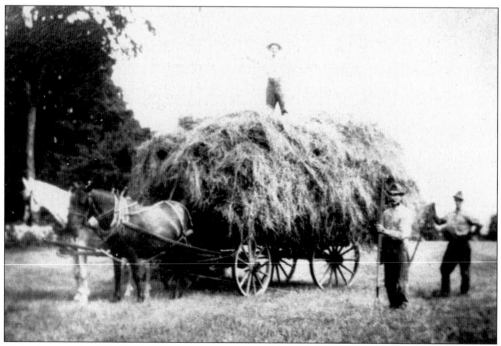

This picture of a fully loaded hay wagon was taken on a Weston farm c. 1912. Farmers used pitchforks to load the wagon. They tossed hay onto the wagon, and a farm hand spread it around to balance the load.

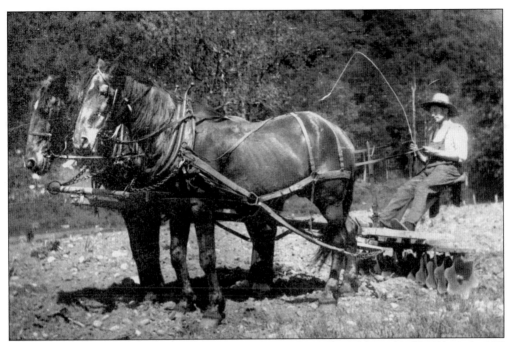

This young farmer, Clarence Chester Smith, age 15, plows the field north of his house at 227 Lyons Plain Road in the spring of 1905.

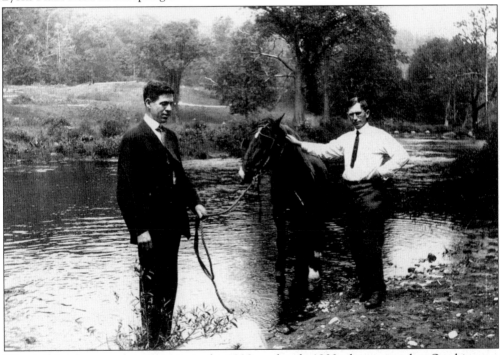

Weston's landscape was more open in the 1800s and early 1900s than it is today. On this open stretch along the east branch of the Saugatuck River, Clarence Chester Smith, right, pats a horse, while an unidentified man holds the reins. The photograph was probably taken in the late 1920s.

This is an undated photograph of the David Osborn house at 61 Georgetown Road. The house and barn were built in 1808. Georgetown, originally called Osborn Town, was a place farmers shopped for supplies. Its rich history includes the Gilbert and Bennett Company, a major manufacturer of wire for screens and fences. Weston is part of Georgetown, which also includes sections of Wilton, Redding, and Ridgefield.

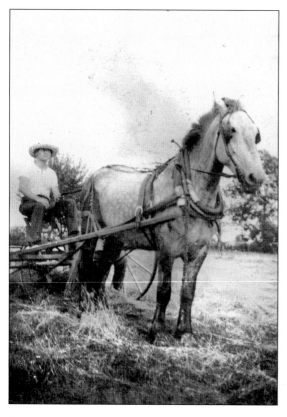

This image shows fall haying at 227 Lyons Plain Road in 1920.

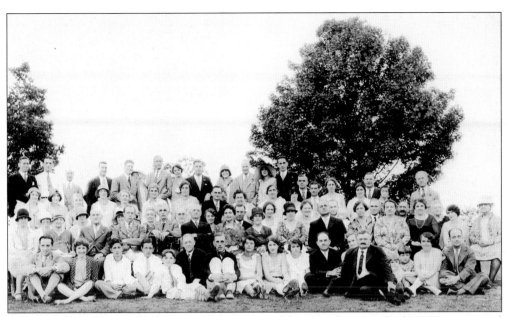

For many years, the Norfield Grange, chartered in 1896, played a central role in Weston social life. This photograph was taken at a gathering on August 31, 1929. Members started the visiting nurses, erected a war memorial, and sponsored scouting.

The Onion Barn in Weston Center, photographed in 1978, was built in 1830, probably by Eliphalet Coley. Onions were Weston's cash crop. The barn was later owned by the Banks family, who raised the Southport Globe variety. When the farm season was over, Frank Banks, who died in the 1940s, worked in Westport as a carpenter.

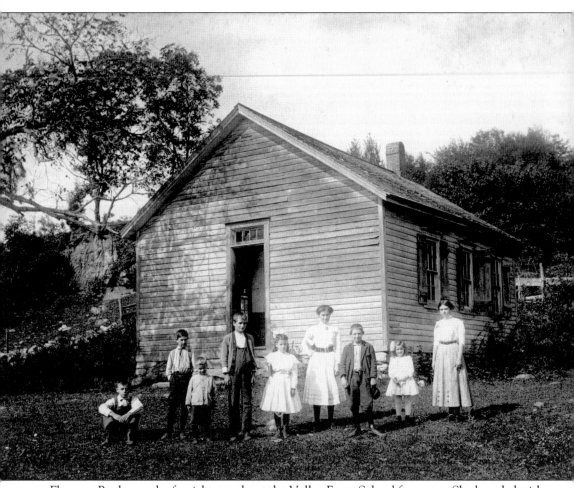

Florence Banks, on the far right, taught at the Valley Forge School for a year. She boarded with the Perry family for $2 a week. School started at 9:00 a.m. and ended at 4:00 p.m. Louise Messex and Anson Morton, among others, were students there. The boys helped the teacher carry in wood for the fire, and both boys and girls took turns fetching water from the well. This photograph was taken in 1912. Attendance records show the names of Beers, Hallock, Rowland, Harcor, and Gould among the group. Children bought their own textbooks and carried their lunches to school. When Florence Banks taught at Valley Forge, her father, Frank, supplied the wood from Devil's Den. As a starting teacher, she earned $25 per month.

# Three

# EDUCATION IS
# OUR BUSINESS

*Cold! Heavens it was terrible. Those were the days of hard winters. The school
teacher had to chop her own firewood or get one of the boys to do it and time
had to be taken out for hand warming before lessons could be commenced.*
—Eula Fancher, teacher at Valley Forge School.

One-room schools began in the 1700s with the Norfield Society, a group that sponsored schools in various geographic areas of the town, which at the time also included land that is now Easton. A school tax was collected and used to fund school in three districts—Lyons Plain, Norfield Center, and Kettle Creek.

Keeping to the schedule of agriculture, which required the help of children on the farm, the early schools were open for only a few months a year. As Norfield's population grew, so did the need for more schools. When Weston was incorporated as a town in 1787, the town took over the responsibility to educate youth. Eight new district schools were formed: Southern, Kettle Creek, Middle, Upper Parish, Osborn Town, Den, Lyons Plain, and Goodhill. These schools were maintained until 1856.

In 1857, a ninth school was added—Valley Forge. By 1870, with changes in population, some districts began closing schools—Kettle Creek in 1870 and Den in 1888. The remaining seven schools operated until the town began to consolidate its education system into a modern school district in the late 1920s.

In 1929, construction began for Horace Hurlbutt Elementary School, which at that time was a four-room schoolhouse, located near Norfield Congregational Church. After it was opened in 1932, the one-room schoolhouses closed. Some Weston residents today recall attending the last of the one-room schoolhouses. The Hurlbutt school was destroyed by fire on October 30, 1963. The 272 students were dispersed to temporary classrooms at Temple Israel and Weston and Westport churches while the school was rebuilt.

Weston traditionally sent its students to Norwalk and Westport for high school. In 1971, it graduated its first class from a new Weston High School. Longtime resident Harry Reasoner spoke at commencement.

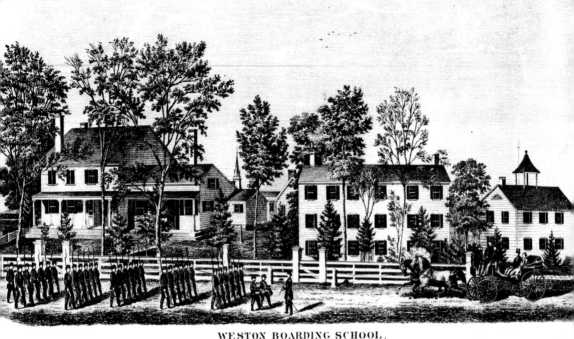

WESTON BOARDING SCHOOL,
A COMMERCIAL AND MILITARY INSTITUTE FOR BOYS.

The Jarvis Military Academy, also known as the Weston Boarding School, operated from 1835–1878 at the southeast corner of Norfield and Weston Roads. In 1997, the town acquired it. The school was founded by Weston town clerk Matthew Buckley. Andrew Sanford Jarvis married Buckley's daughter and became headmaster, giving it the name Jarvis Military Academy. The boys' school was considered second only to West Point in the quality of its training cadets. Originally, the site hosted several more buildings than exist today, including a chapel, dining hall, and dormitories. Luster alone could not keep the bank from foreclosing in the 1880s, and Horace Hurlbutt bought the property and rented it to the Weston Grange. A student writing in the school newspaper described how they created a skating pond by damming wetlands on land across the road.

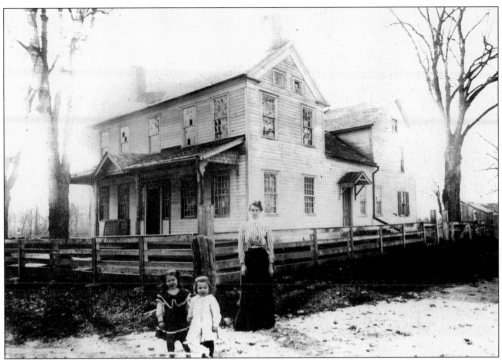

This house was used as a dormitory for the Jarvis Academy. Located on the southeast corner of Norfield and Weston Roads, it was razed in 1914. Willis, the son of Fred Banks, built his home there. It is now the Norfield Congregational Church parsonage.

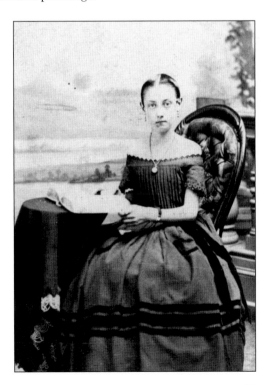

A studious-looking Fannie Coley is seen here c. the 1860s.

Kettle Creek School is shown here in the early 1900s, after it was moved to its current location at the corner of Old Weston and High Acre Roads. For a time, it was part of the Coley homestead at 104 Weston Road. While it has been modified for use as a private residence, it still retains its original charm.

Shown here is the Goodhill Road School when it was in use in the early 20th century. It was incorporated into the house at 172 Goodhill Road and is still distinguishable.

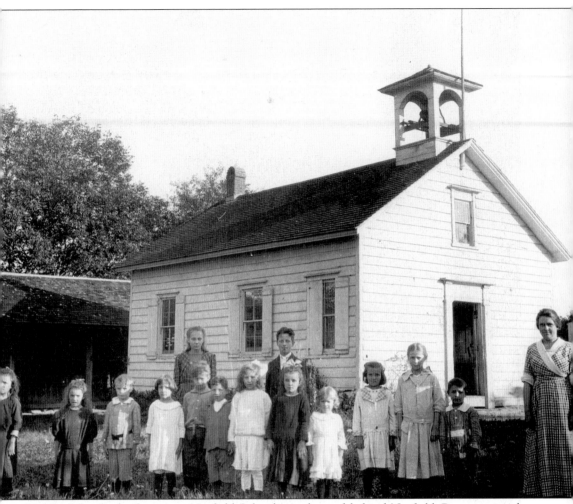

Middle School, also known as Norfield School, was located behind Norfield Congregational Church. In this 1917 class photograph, the teacher, Florence Banks, poses with her class. The students in the front row are, from left to right, Henrietta Canfield, Estelle Canfield, Alex Martin, Charlotte Broch, Myron Waterbury, Oscar Westerling, Hilda Westerling, Marguerite Canfield, Lillian Broch, Dorothy Martin, Elizabeth Martin, and Joseph Martin. In the back row are Florence McCarrol (left) and Kenneth Fitch.

Because of its central location, Middle School was often used as a gathering spot for system-wide sponsored events, such as end of the school year field days, which featured outdoor races and other activities.

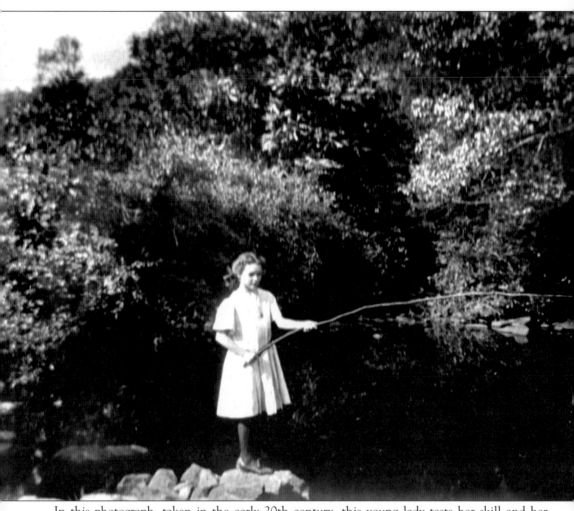

In this photograph, taken in the early 20th century, this young lady tests her skill and her homemade fishing pole at one of Weston's numerous fishing spots.

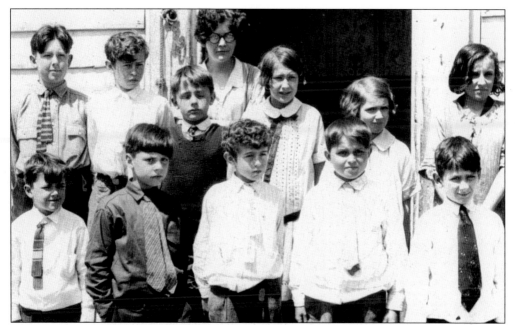

Helen Budd Mason was 18 years old when she taught this Norfield (Middle) School class in 1923. Wearing eyeglasses, she stands behind her students. In the second row, third from left, with his eyes closed, is Charles Daugherty, son of the famous American artist James Daugherty. The Daughertys were new in town when this photograph was taken. Charles became an accomplished artist and continues to paint at his Weston studio.

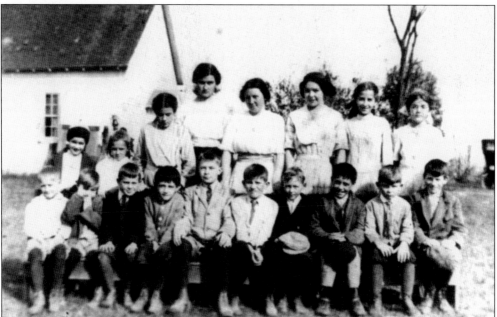

Pictured is another Norfield class fondly remembered by Helen Budd Mason (1905–2003), but in this one she was a student. She started teaching when she was barely out of high school. She went on to earn bachelor's and master's degrees. She grew up on Kettle Creek Road and her father, Oscar Budd, was a three-term selectman.

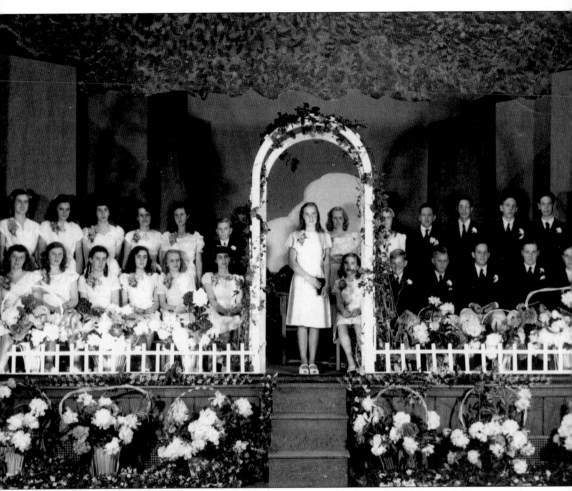

When fire marshall Fred Moore graduated from the Hurlbutt School Class of 1945, students attended kindergarten through eighth grade. They went on to Staples High School in Westport. Moore is seated at far right, at the end of the first row. He recalls that the building, which later burned down, was a beautiful one-story structure with WPA murals.

Helen Hansen Rosendahl, who was Weston's town clerk from 1984 to 1991, graduated from Hurlbutt School in 1939. With the Weston landscape as their background, the 13 members of the graduating class pose outdoors with their teacher. Rosendahl is fourth from the left in the front row.

After Hurlbutt's commencement, Helen Rosendahl poses in her parents' yard on Maple Street. Her three children are Hurlbutt graduates. She married Bert Rosendahl, a World War II hero, who retired from Gilbert and Bennett. They live on Old Farm Road in the house her uncle built.

Seen here is the Hurlbutt School Building Committee in the late 1920s. Members included Willis Banks, Dottie Holbrook, and Ray Fitch.

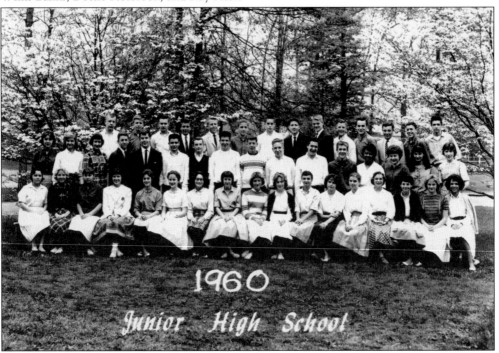

Dogwoods frame the happy faces of students in this class.

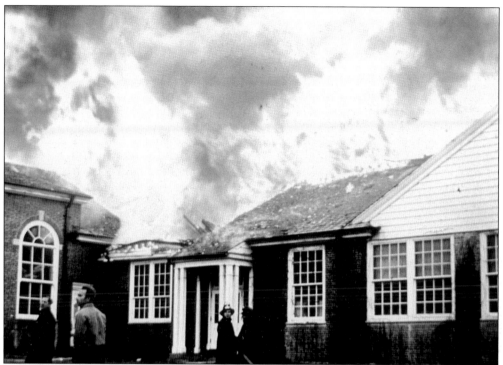

Before 6:00 a.m. on October 30, 1963, a milkman delivering to Hurlbutt saw smoke. The fast-burning fire, located at the center of the building, spread through the roof. Weston firefighters were aided by surrounding towns. The fire destroyed 12 classrooms for grades four through six, the gym, and the library. Firefighters kept the fire from spreading to the East House and South House buildings.

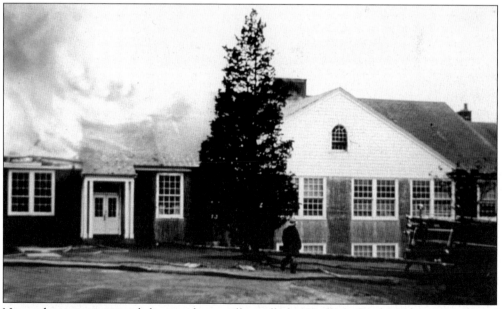

No students were injured, but residents still recall the Hurlbutt fire and say it was one of Weston's saddest days. In 1965, a new building replaced the one destroyed by fire.

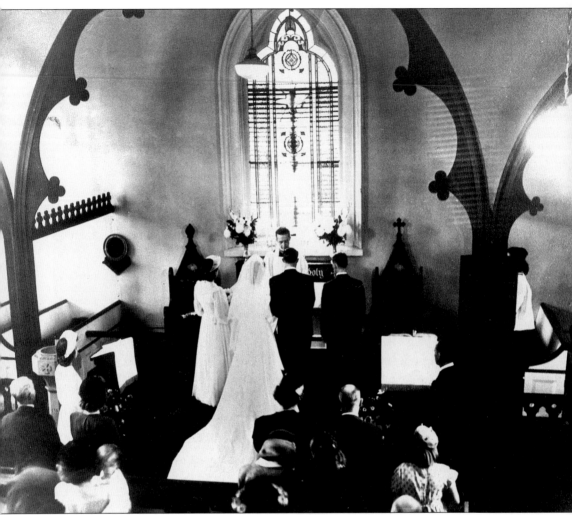

Julia Gjuresko and Robert Studwell were married at Emmanuel Episcopal Church in 1945, 100 years after its founding. Located at the end of Lyons Plain, near Kellogg Hill, the church continues to flourish and attracts community-wide attendance at its annual fair. Hanford Nichols, a town selectman and large landholder who lived at 282 Lyons Plain, wanted the church to be located in Weston. Older members wanted it located in North Fairfield, which is now Easton. After Easton separated from Weston in 1845, Nichols led support for construction of a new church in Weston.

# Four

# LYONS PLAIN

*Folks used to come from all over the countryside, on foot,*
*on horseback and any way they could to get here.*
—Frank Lyon, 1932, recalling the popularity of the Banks Tavern.

The Lyons Plain section of Weston, named after the Lyon family, is bisected by one of the cross highways laid out by Fairfield's early settlers. Originally, the road linked Weston with Redding and Danbury. After the Bridgeport Hydraulic Company built the dam in Valley Forge, that link was submerged beneath the Saugatuck Reservoir. It remained a state highway until the 1950s, when it became a town road.

Early surveyors mapping the town spelled Lyons Plain in a variety of ways. An 1867 map spells it "Lyons Plains." A decision on the current spelling was handed down in Washington, after a new resident, discovering three different spellings, wrote the U.S. Department of Interior in 1947.

Industry and farming existed side by side on Lyons Plain through the early 1900s. The *Atlas of Fairfield County* in 1867 shows the Lyons Plain business district. It included a button factory, grocery store, manufacturer of "hay cutters and other improved Agricultural implements," and grist and plaster mills. The largest employer was the G.W. Bradley Edge Tool Company.

The house directly north of Emmanuel Church was built by Walter Treadwell in 1845. At one time, town business was conducted there. Sarah Treadwell served as town clerk from 1932 to 1945. The Hanford Nichols home at 282 Lyons Plain is another local landmark. The Banks Tavern, built in 1730, is well documented as the popular nightclub of its day, from 1787 to 1871. It operated at 266 Lyons Plain and is a private residence today. Sleighing parties made it a regular stop and the tavern's signature beverage, Flip, a mixture of ale and rum, kept many a patron warm on a cold winter's eve.

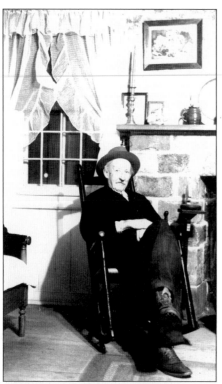

Frank Lyon, a descendant of the original Lyon family, rocks his chair next to the fireplace in the former Banks Tavern. He spent a winter there when it was owned by Albert Gerhardt, whose father purchased it from the Banks family. Frank, who was 80 when this photograph was taken in 1932, recalled late nights of dancing at the tavern.

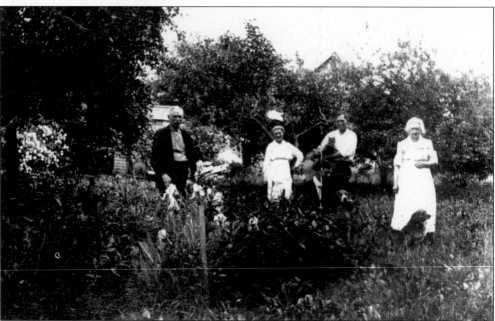

James A. Smith (1893–1902), a first selectman, is seen in the apple orchard and flower gardens of his home at 227 Lyons Plain Road. From left to right are James A. Smith, Harriet Frances Coley Provoost, an unidentified man kneeling with a dog, Clarence Chester Smith (the son of James), and Clara Ella Coley Smith (the wife of James). Clara Smith and Harriet Provoost were sisters. They grew up in the home their grandfather built at 227 Lyons Plain Road.

This is the house at 227 Lyons Plain Road photographed from the south side, looking north, c. 1915. The Victorian-style porch was demolished in 1969 and was not original to the home built in 1838 by Samuel Banks. The well house is located outside the kitchen door.

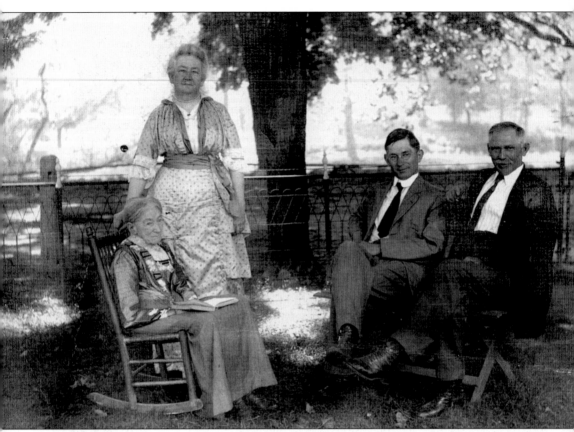

In the rocking chair is Harriet Bradley Banks Coley, widow of Frederick Coley, who died only a few years after they were married in a wagon accident on River Road. (Her portrait as a young woman appears on page 11.) She moved back home with her two children and spent the rest of her life at 227 Lyons Plain. Her daughter, Clara Ella Coley Smith, stands by her side. Clara's son, Clarence Chester Smith, born in 1890, sits next to his father, James A. Smith, who is at the far right. Harriet was the daughter of Samuel Merwin Banks, who built the house at 227 Lyons Plain and died in 1873. His father, brother, and nephew were all named Thomas Banks.

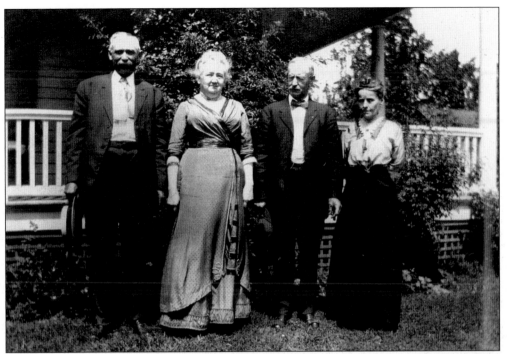

James and Clara Smith entertained Eli and Mary Wakeman at their home c. the early 1900s. Wakeman was the town treasurer.

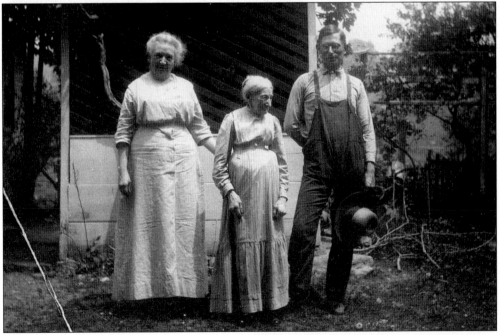

The well house was still operating in 1917 when this photograph was taken at 227 Lyons Plain Road. It was demolished in the early 1950s. Seen here are Clara Smith (left); Clara's mother, Harriet Coley (center); and Clara's son, Clarence. The yard outside the kitchen door is a typical farm scene. Strewn with castoff objects, no grass grows in the dirt yard.

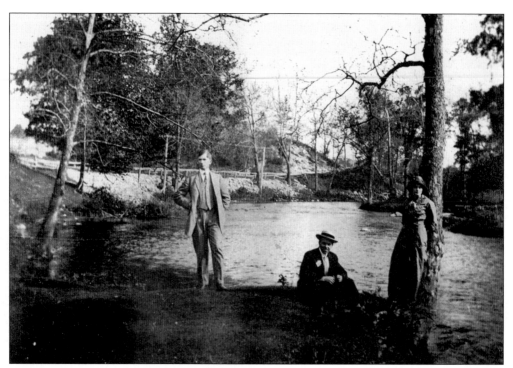

A leisurely Sunday afternoon was spent by Clarence Smith, left, and friends along the Saugatuck River in the 1920s. The landscape features a noticeable lack of trees compared with today. Lyons Plain Road is in the background.

Pictured is Willis Lyon *c.* 1900.

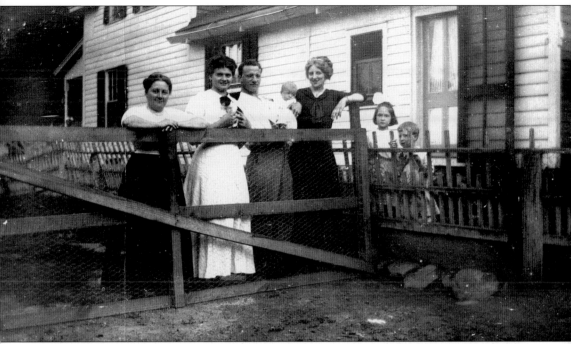

Fred Schneider Sr. holds his son Frederick E. Schneider, born on December 14, 1906, in the rear of a home next door to the George W. Bradley House, 110 Lyons Plain Road. To the right is his wife, Emily, and to the left is Mrs. George Sherwood. The Schneiders of Mount Vernon, New York, often visited the Sherwoods. Some years later, when the young Fred developed asthma, doctors recommended the boy go to the country where the air was fresher. Between 1914 and 1916, he attended the one-room schoolhouse on Lyons Plain Road while living with the Sherwoods. Frederick E. Schneider's son is Frederick W. Schneider, a New York City native who settled in Weston in 1981 with his wife, Shirley. Both are active in the community and Norfield Congregational Church.

Emily Schneider tends to a calf outside a barn owned by George Sherwood. In 1935, Dubois Morris Sr. moved the barn to 104 Lyons Plains Road, where he bought property after long service in the missions of China. His son, Dubois Jr., lived there until 2000 with his wife, Bootsie. Dubois Jr. wrote and recited his own poetry from memory and was honored as Weston's poet laureate in the 1990s before relocating to Vermont to be near his children.

Children on a donkey cart on Lyons Plain Road are pictured here *c.* 1916.

George Sherwood and his wife (right) and Fred Schneider Sr. and his wife are pictured *c.* 1916, in front of the Sherwood House on Lyon's Plain Road.

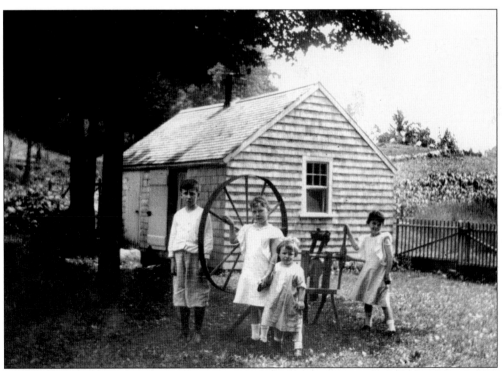

Frederick E. Schneider and playmates are pictured here near a spinning wheel in George Sherwood's yard in 1914.

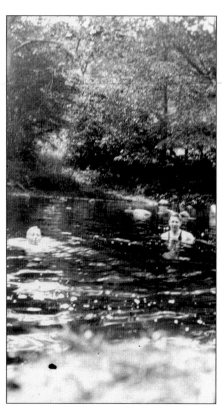

The old swimming hole on the Saugatuck River behind what became the Morris home on Lyons Plain Road offered cool refreshment to young and old alike in the summer of 1916.

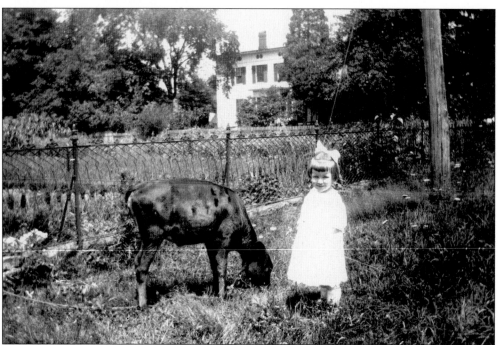

Mildred Schneider, younger sister of Frederick E. Schneider, admires a calf grazing in front of the G.W. Bradley house at 110 Lyon's Plain Road.

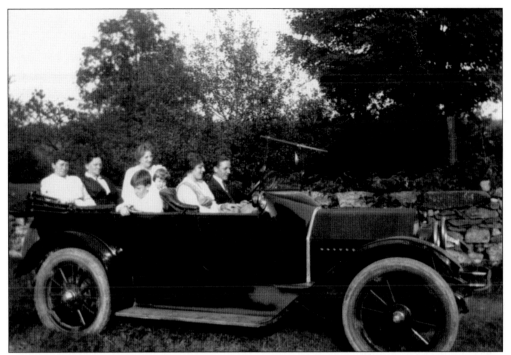

In 1917, Sunday family drives were popular along the straight and long Lyons Plain Road. Here, the Schneider and Hohn families share the fun.

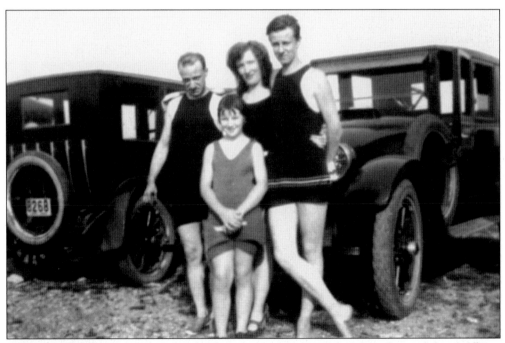

Fred Schneider Sr. is seen with his children, Mildred and Fred E. Schneider, and the children's aunt, Elsie Klein, in 1924 at Compo Beach on Long Island Sound in Weston's neighboring town of Westport, where Westonites enjoy the beach.

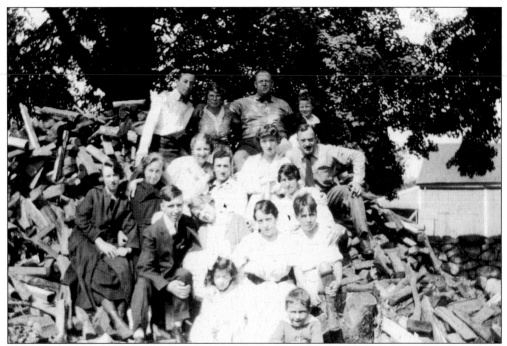

Wood is piled high, ready for a Weston winter. In the middle are Frederick Schneider and his wife before the birth of their son, Frederick E., in 1906.

Frederick E. Schneider (left) and his sister, Mildred (second from right), play out a scene from the early days of shared times among European settlers and Native Americans.

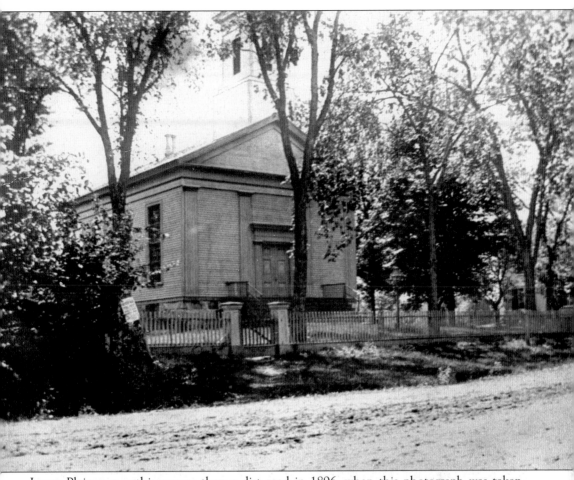

Lyons Plain was nothing more than a dirt road in 1896, when this photograph was taken. Although times have changed, history reflects itself in the churchyard, where many of Weston's distinguished citizens rest. U.S. Supreme Court Justice John Marshall Harlan, appointed by President Eisenhower in 1955, is buried there. His funeral on January 4, 1972, was attended by the court's justices, who flew from Washington to New York and traveled by limousine to Weston. The Secret Service checked the church thoroughly before the funeral began.

This *c.* 1950s picture shows flooding on the Saugatuck River near the home of writer Webb Waldron. (Photograph courtesy of Charles Niewenhous.)

# Five

# ACTS OF GOD AND MAN

*Our fight against the Bridgeport Hydraulic Company's proposed reservoir,*
*which would flood one of New England's historic beauty spots, is not merely an immediate*
*local issue. It exerts a serious influence on the future safety of Fairfield County's watershed.*
—John Orr Young, president of the Saugatuck Valley Association, 1938.

Few events can compare to what happened in Weston on December 1, 1807. That morning, at 6:30 a.m., a "blazing fireball, appearing to be about two-thirds the size of the moon" fell in six places in Weston, according to Barbara L. Narendra, curator of Yale University's meteorite collection. It was the first recorded meteorite fall in America.

The Weston meteorite established Yale professor Benjamin Silliman as an international expert and launched Yale's geology collection at the Peabody Museum. The meteorite story reached President Thomas Jefferson, who, at first, treated it as a joke. "Gentlemen, I would rather believe that those two Yankee professors would lie than believe that stones would fall from heaven," he said.

Major storms and hurricanes left their mark on Weston. On Friday, October 14, 1955, shortly after the Brooklyn Dodgers had just won their first and only World Series, rains filled the skies. Water ran over ground well saturated by a rainy stretch that began with two August hurricanes. Without warning, the earth began to move. The swift and powerful forces of rising water tossed aside Cadillacs and Buicks like toys. Newly formed gullies upended and swallowed cars and homes. On Monday, October 17, the torrents stopped. Four people were dead in the area. Homes, businesses, roads, bridges, and dams took years to repair.

According to old timers, the worst thing that happened in their time was the destruction of Valley Forge to build the Saugatuck Reservoir. Angry protestors included famous residents and native sons. John Orr Young, who founded the New York advertising firm Young and Rubicam, united the group under the Saugatuck Valley Association. The colorful fight dragged on for years. The Bridgeport Hydraulic Company prevailed, and homes, barns, and roads that had been part of Weston's iron industry were submerged beneath the reservoir. Like Brigadoon, the village outlines reappear, revealing the past, when dry spells reduce the reservoir's water level.

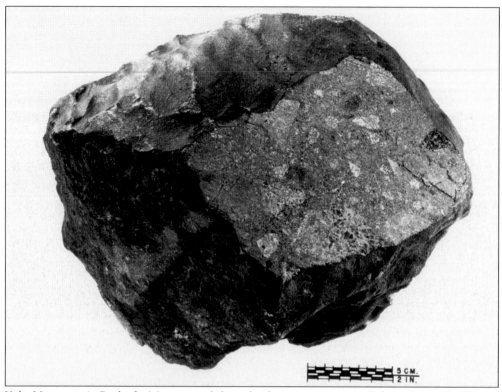

Yale University's Peabody Museum exhibits the largest specimen of the celebrated Weston meteorite, America's first documented meteorite fall. After Easton's incorporation in 1845, the location of the fall near Route 58 became part of that town, but scientists still call it the "Weston Meteorite." (Photograph courtesy of Yale University.)

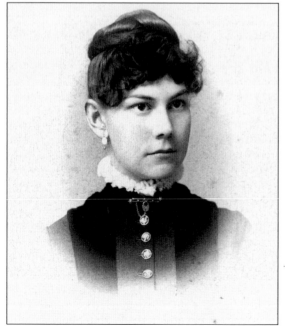

In her diary, Carrie Morehouse, age 22, recorded the Blizzard of 1888 in Weston. Snow began to fall on the afternoon of March 11. "The banks in places were 8 to 12 feet high," she wrote. Travel on Newtown Turnpike ceased. Finally, on March 22, the first travelers were seen. She noted the event, stating "a horse hitched to a wagon went by here."

Construction on the Senior Dam along the Saugatuck River began in the late 1930s. Ancient farmers' meadows gone fallow spread around the construction site, where a bulldozer in the foreground prepares the site for major civil works and radical change.

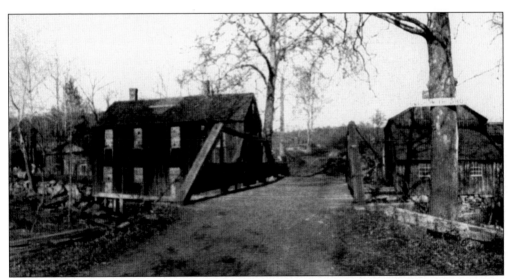

Industry thrived in Valley Forge, where now the 14-billion-gallon Saugatuck Reservoir sits. In this 1903 photograph by Burr McIntosh, are, from left to right, the dam, Hull's Sawmill (later Osborn's), Hull's Foundry (later Wheeler's), and, across the bridge, the Pattern Shop.

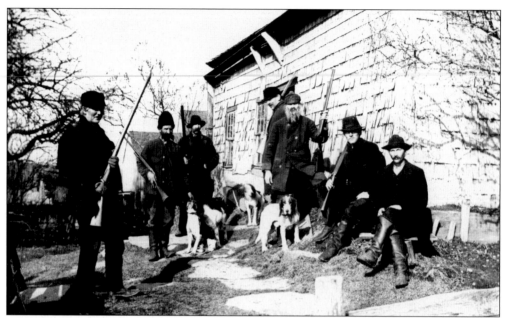

The land met the needs of Weston's early residents, who farmed, fished, and hunted for food. These coon hunters and dogs were photographed in Valley Forge.

This gentleman and a dog keep restfully cool on a summer's day under the old oak tree in Valley Forge.

Dr. Frank Gorham, Weston's health officer, pays a call to a Valley Forge home. This house was salvaged and moved before the region was flooded.

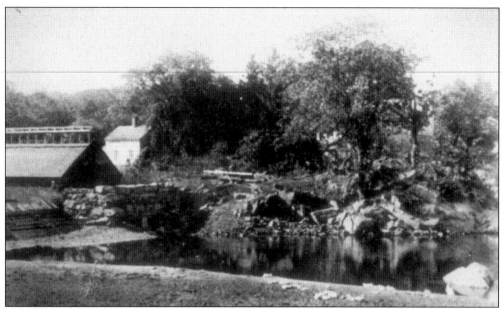

Franklin Bulkley owned the iron foundry pictured here, which was one of two in Valley Forge. It was located on the west bank of the river, and Hull's Foundry was on the east. Up from Buckley's were a blacksmith and a shop that made beaver hats.

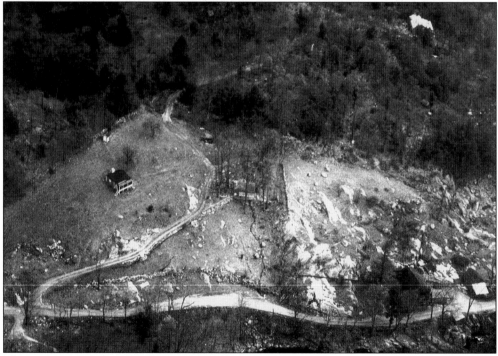

This 1930s aerial photograph reveals a stark, rocky landscape stressed by years of tree clearing for fuel and lumber, livestock grazing, and meager farming. Valley Forge Road clings to the edge of "the Glen," carved by the rushing waters of the Saugatuck River before the construction of the Senior Dam, just a few hundred yards upstream.

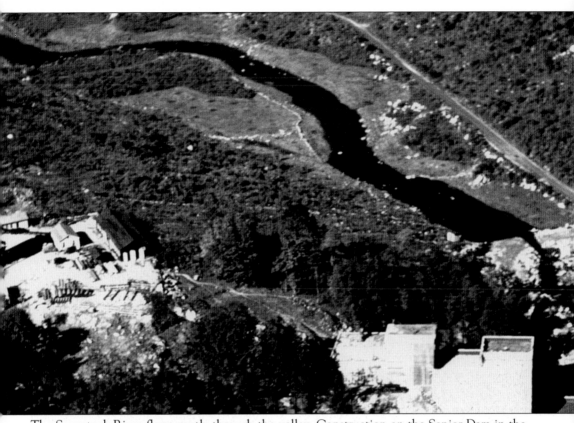

The Saugatuck River flows gently through the valley. Construction on the Senior Dam in the foreground is underway.

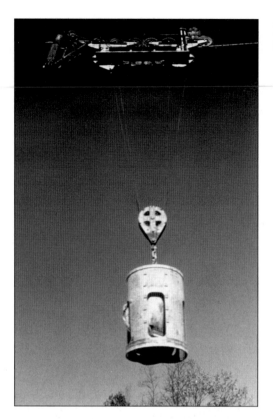

Lifted aloft, this equipment moved concrete for constructing the dam in 1939.

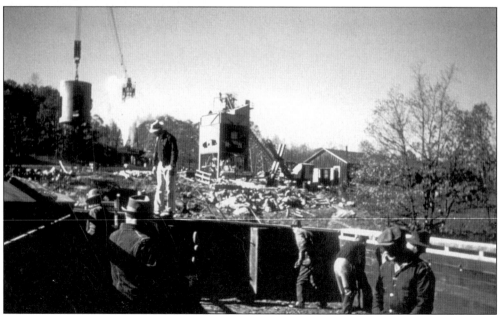

Workers on the Senior Dam labor under an autumn sky. The reservoir was constructed to serve Fairfield County's growing population and manufacturing industry.

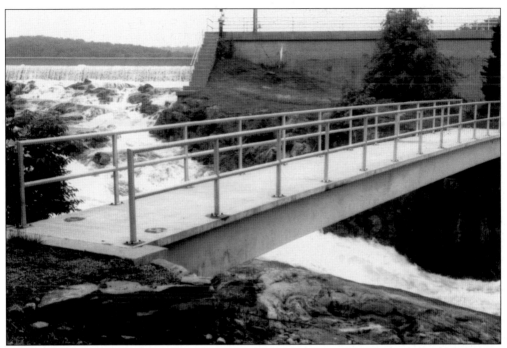

Water rushes under a bridge at the completed dam.

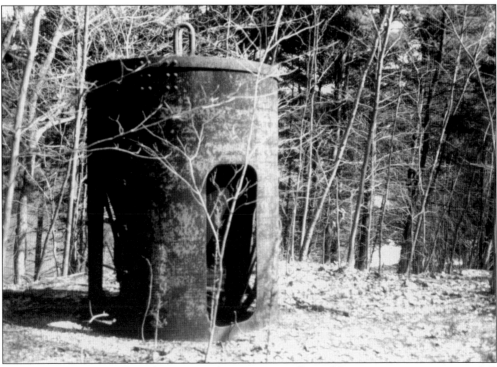

Hikers and fishermen along the Saugatuck River may still stumble upon some rusting items left after construction.

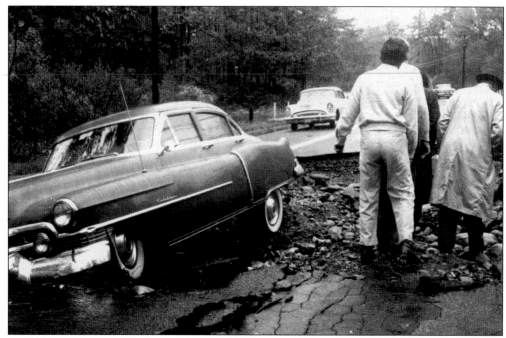

The photographs on these pages capture some of the damage to town roads by the 1955 flood. They are from a family collection given to the Weston Historical Society. Here, Kettle Creek washes out Route 57, south of Weston Center.

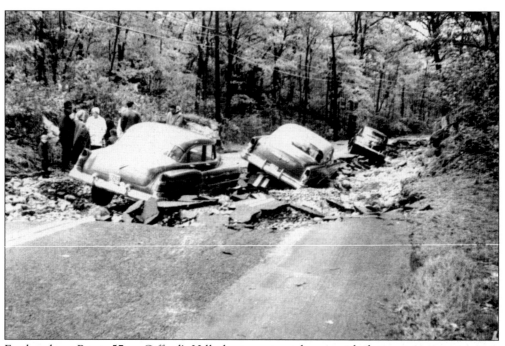

Further down Route 57 on Gifford's Hill, the torrent catches up with three cars trying to escape the tide rushing south.

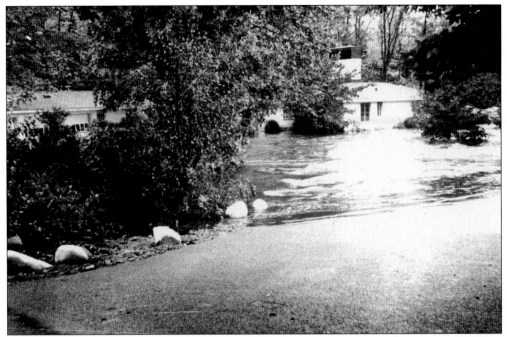

A house, overwhelmed in the path of the spreading creek, reportedly had just been sold days before the deluge.

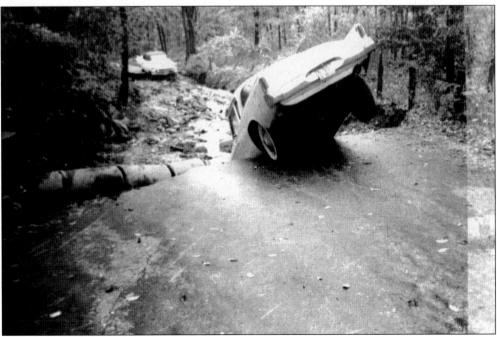

Back up on Norfield, a driver and passenger narrowly escaped certain peril when a bridge collapsed.

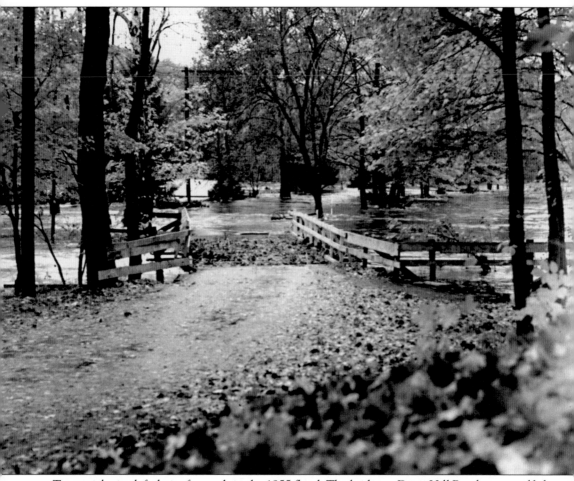

Torrential rains left their aftermath in the 1955 flood. The bridge at Davis Hill Road was engulfed by water rushing south on the Saugatuck River. (Photograph courtesy of Charles Niewenhous.)

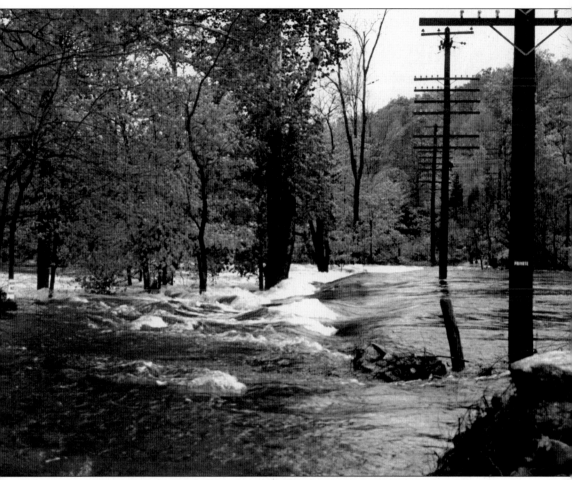

This section of Lyons Plain Road was impassable after the October 1955 storm hit. (Photograph courtesy of Charles Niewenhous.)

# VOTERS OF WESTON—BE GOOD HORSE TRADERS

The Bridgeport Hydraulic Company offers $37,500 BONUS if we will stop our fight against their dam and the destruction of Valley Forge.

This sum is not for the roads; they HAVE TO REPLACE the roads under the law. This sum is a bribe to keep this fight from going to the United States Supreme Court.

## The Fight Won't Cost The Town of Weston One Cent!

The Hydraulic has already taken it to court to scare us. The Saugatuck Valley Association has guaranteed the court costs and posted a bond for it.

## The Dam Won't Lower Your Taxes!

The Hydraulic owns one-third of the town of Easton. They pay one-third of the taxes — a rate kept low by law. When Easton's taxes are raised, as they will be, the Hydraulic's taxes will not be. The town takes the rap. So would we.

## They Offer One Million Gallons a Day

Any competent engineer will tell you that is equal to a stream 18 inches wide, 3 inches deep. Don't be fooled by their indefinite promises.

The Hydraulic Company has no proof of their necessity for this water!

We have a strong case. They know it. That's why they are trying to buy us off on the eve of the first court hearing on this necessity.

## Governor Cross Has Promised Us His Aid!

Wait and see what he can do. If you sell out, you've sold your rights forever — for $37,500.

## Let's Remember We Are Americans!

Don't let a privately owned utility company be dictator in our town! God gave us the water. Why should we let it be taken to Bridgeport to enrich the Hydraulic stockholders?

## Come to Town Meeting Wednesday Night! Vote Against This Bribe!

# VOTE NO!

Civic pride has always run strong, as this 1938 poster from the ad hoc citizen group, Saugatuck River Valley Association, demonstrates.

# Six

# OUR TOWN

*June Havoc came before the Zoning Board of Appeals one hot summer evening.
All seven of the men arrived with their neckties on, instead of wearing their usual shorts. They were
really quite dressed. June Havoc arrived in a brilliant, batik muumuu. They were quite
disappointed. They expected her to dress up, too. She got her variance. No problem.*
—Gertrude Walker, town clerk (1945–1984).

As a snapshot of life, Weston could easily have been the setting for the Pulitzer Prize-winning play "Our Town," written by Thornton Wilder, who taught nearby at Yale and died in New Haven's St. Raphael's Hospital in the mid-1970s.

Like Wilder's characters, whose daily lives reflected universal themes, Westonites share certain common interests. Core values of family, education, good governance, and volunteerism are still important. Conservation of our natural resources and open spaces and prudent land management are priorities.

Over the years, Weston has attracted residents whose wealth and international fame make it possible for them to live anywhere. They selected this small New England town, where daily events still touch the lives of people, and where government depends on the active participation of all citizens.

Staunch and generous members of our community continue to reach out to those in need. Local organizations look beyond the town's borders in offering help. Changes are occurring in town, but that has been true over time. For a small town, Weston has a fascinating history that continues to enrich the lives of its citizens and offers lessons for generations to come.

Transportation improvements brought newcomers to town in the 1920s.

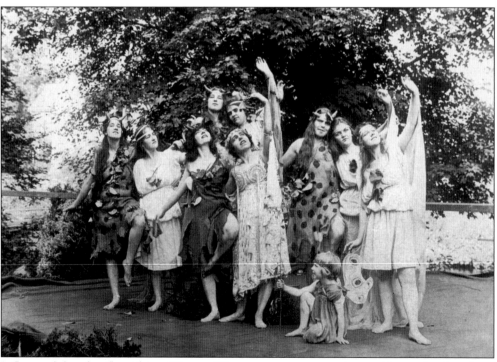

Influenced by the flourishing Weston-Westport arts community, residents developed an interest in the arts.

In this view looking north toward Weston Center is Weston Road at Gifford's Hill. This photograph was taken before state improvements to Route 57 were made.

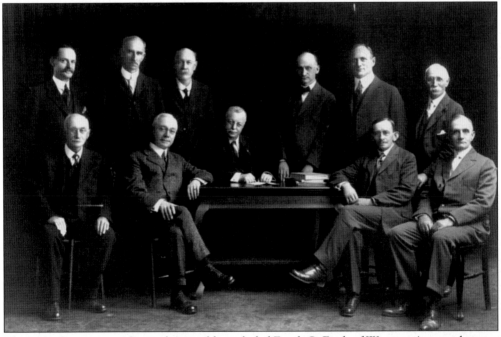

The 1921 Connecticut General Assembly included Frank C. Fitch of Weston. Among the men standing, he is fifth from the left. He was a member of the Committee on State Parks and Reservations.

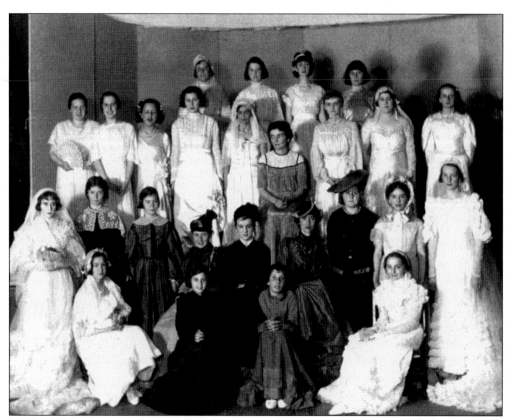

In the 1930s, the out-of-town trip for entertainment was still a rarity, so Weston's youth developed local events, including this wedding pageant in 1935. No doubt this activity, which included combing old trunks for gowns, kept them busy. Before she died, Helen Budd Mason identified the people pictured for the Weston Historical Society.

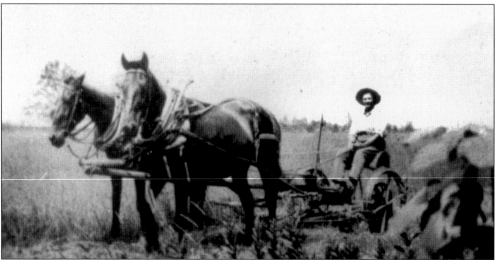

Oscar Budd (1869–1966) mows hay on the family's large farm in 1920. During his 50 years of service to Weston (1899–1947), he held almost every public office, from first selectman to registrar of voters.

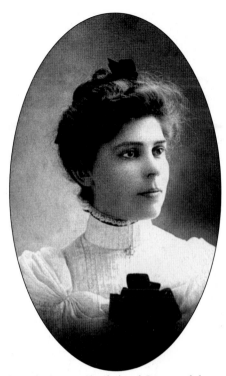

Oscar Budd (left) is pictured at age 18 in 1887. Mabel Fitch Sturges (right), of Cannondale, is shown at age 23 in 1900. She married Oscar Budd in October 1902, and they had two children, Edward and Helen.

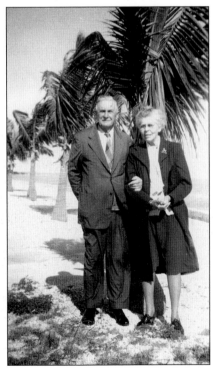

Oscar and Mabel Budd retired to Florida, where this picture was taken in 1946.

Dressed in their Sunday best, these Weston visitors stand on rocky outcroppings along the Saugatuck River. This early postcard identifies the location as "the Forge."

Photographed for this postcard was a rustic bridge at "the Glen."

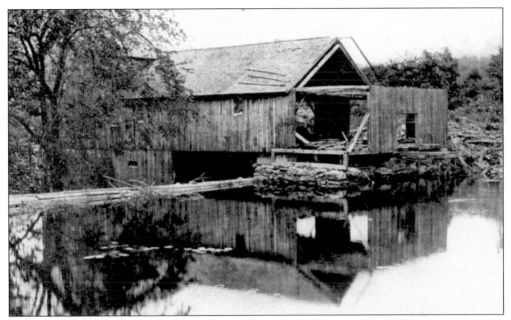

This *c.* 1900 scene of the old Davis Grist and Sawmill, later Cobb's Mill Inn, appears on a postcard the Wilton Historical Society donated to the Weston Historical Society.

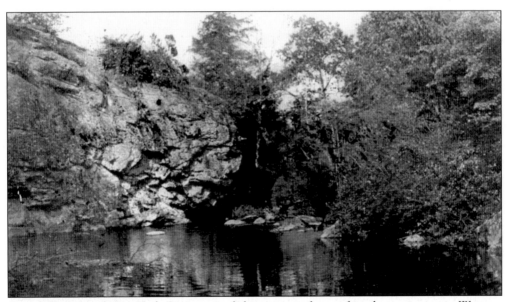

George Barbour of New York City received this message from a friend vacationing in Weston: "Sorry vacation is so near over." The scene is identified as "the Devil's Mouth."

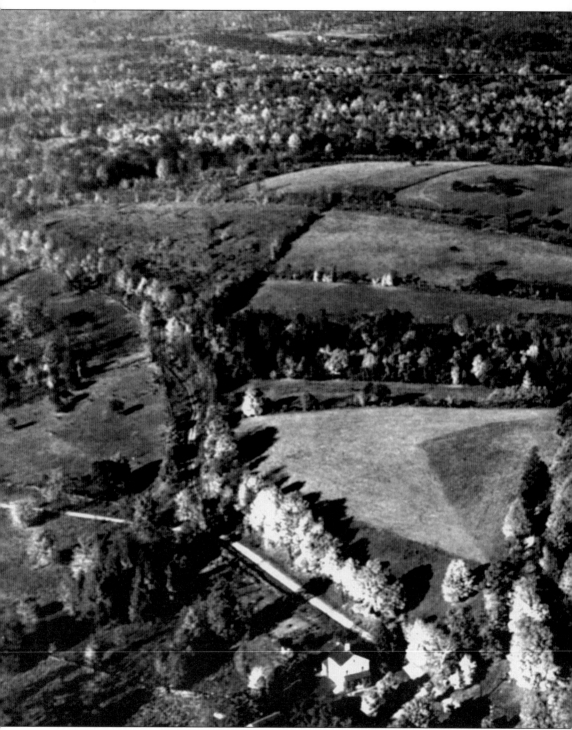

A 1930s aerial view of Kellogg Hill shows the Edward Hall Faile farm at the top of the hill. Electricity had just been installed. David H. Faile Jr., of Fairfield, said his grandfather bought the farm before the Great Depression and sold it in 1950. As an engineer, Edward Hall Faile

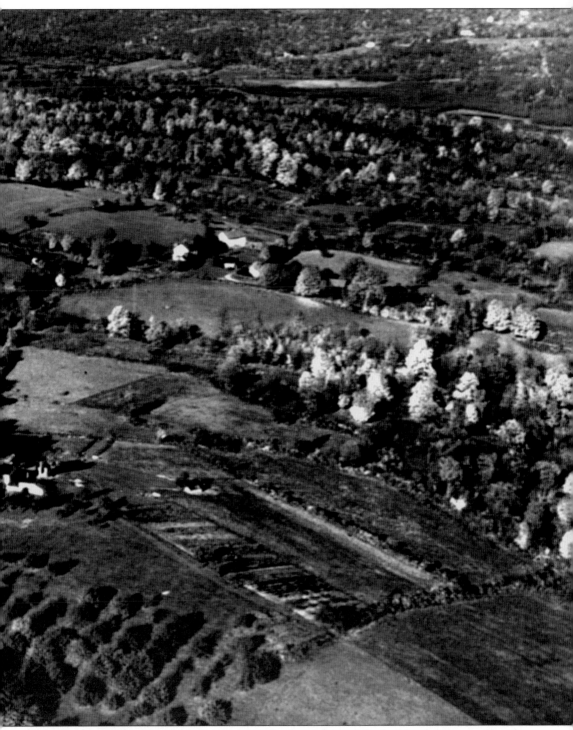

designed Rockefeller Center and the airport in Providence, Rhode Island. His son, David, worked on the farm, attended Hurlbutt, and bought a former tannery at the north end of Goodhill Road, where David Jr. grew up.

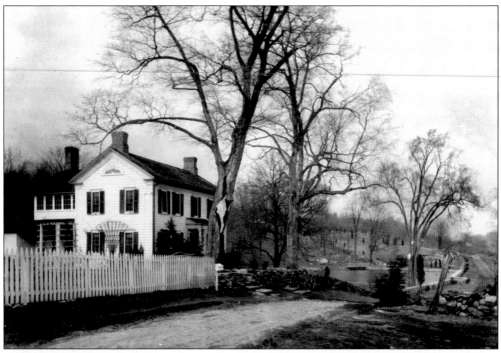

In the foreground of this 1930s photograph is the Bulkley Home at 96 Ladder Hill Road North. Built before the American Revolution, the residence's original fireplace is still in use.

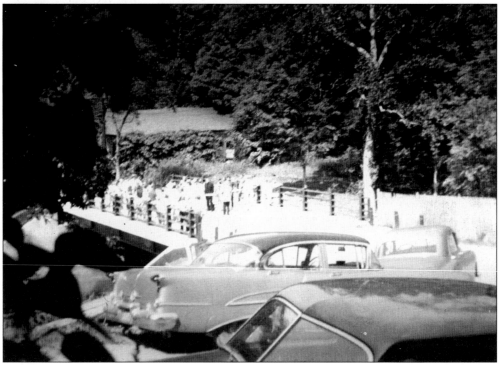

In 1955, this bridge across the Saugatuck was dedicated. It was built on the site of the David Coley foundry.

The house at 446 Newton Turnpike, built in 1845, is another Bulkley home and was owned by the late Jim Hoe. Pictured are Libby, Jim, Linda, Vaughn, and Jimmy, driving away in one of the many Duesenbergs Hoe owned over the years. He was acknowledged as the leading Duesenberg restoration expert in the East.

New York journalists Grace Robinson and her husband, Robert Conway, moved to the old tollhouse on Newtown Turnpike in 1922. The stone pillar still stands. Writing to a friend in the late 1930s, she said, "Weston is mightily changed from the last time you saw it. There is an improved road running past my house. We have electricity."

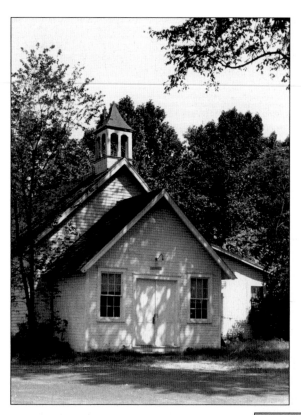

This was Weston's town hall until a spectacular late-night fire destroyed it in 1951. Built behind Norfield Congregational Church on land donated by Thaddeus Burr, it dated to 1884. In 1938, a wing was added for the town clerk's office.

Barbara Wagner and John Hammerslough work the phones in Wagner's 1973 bid for first selectman. She was the first woman elected to lead the town and served until 1975.

Sen. George Guidera, seen with his family in 1975, grew up in town and served six terms as first selectman, from 1987 to 1999. Pictured are, from left to right, Karen, Suzanne, Linda (his wife), George, Barbara, and George Jr.

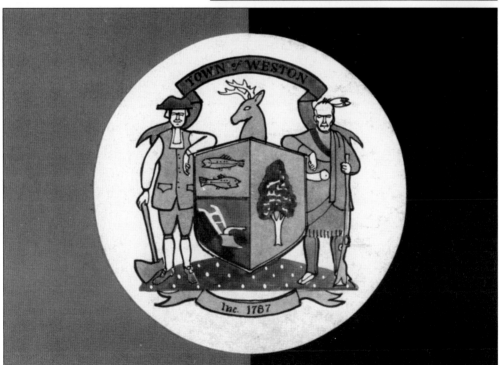

Weston's official seal was designed by artist and former constable Blake Hampton in the 1980s.

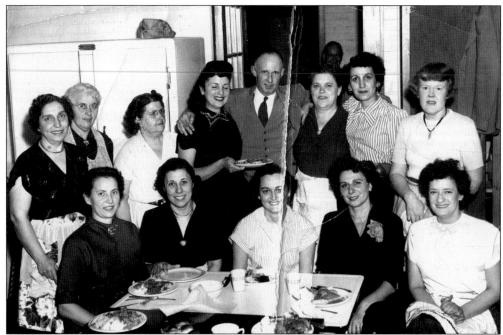

From 1932 through the 1940s, the community gathered for the annual Firemen's Frolic. Chief John O'Brien, who served from 1944 to 1970, thanks the cooks. Standing to the right of the chief are Janet Guidera, Mimi Castro, and Mrs. John Brietwiser, the town treasurer's wife. Standing at far left is Mrs. Stanton Fancher, whose family farm was across from the Grange on Goodhill Road. Seated on left is Rose Bross, and on the far right is Mrs. Milton Youngling.

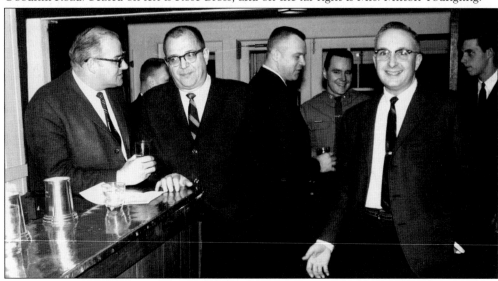

Firefighters and resident state troopers gather for the annual social at the Lyons Plain firehouse. Seen here are, from left to right, Joe Spetly, who drives school buses; the late Bob Stein, who drove the town ambulance; troopers Albert Kruzshak and David Rochavansky; and Paul Deysenroth, volunteer firefighter and current president of the Weston Historical Society. Before Weston had a police department, law and order was in the hands of resident state troopers and volunteer constables.

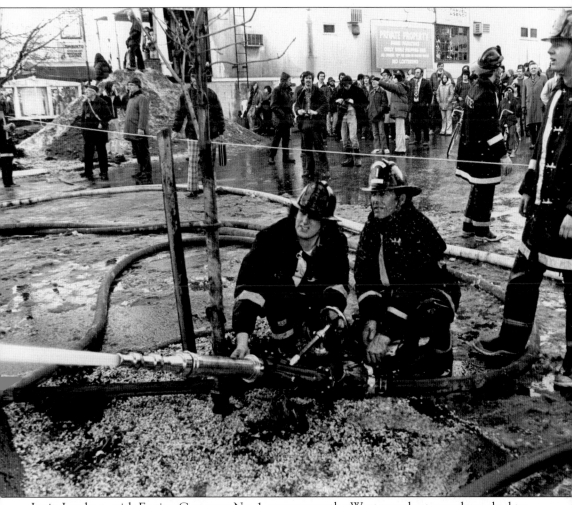

Irwin Lambert, with Engine Company No. 1, was among the Weston volunteers who rushed to the aid of Westport on February 9, 1976, to fight a general alarm fire at Sloan's Furniture Store. The blaze threatened to destroy downtown but was brought under control by firefighters. In recent years, Lambert has been driving the "Wednesday bus" for seniors.

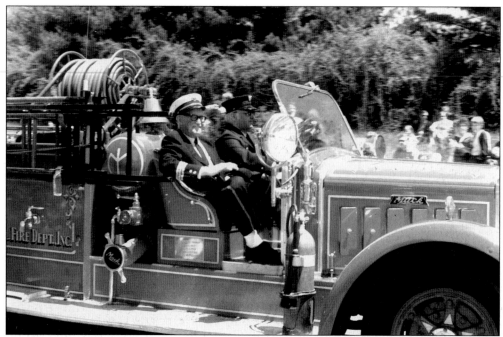

To honor the volunteer spirit and sacrifices of veterans, emergency personnel, and others, citizens gather each year for the Memorial Day parade. In this 1968 photograph, John O'Brien, the fire chief, is driven along Route 57 in the department's first truck, a 1934 Ford, used today on special occasions. O'Brien was Weston's second chief, serving from 1945 to 1970.

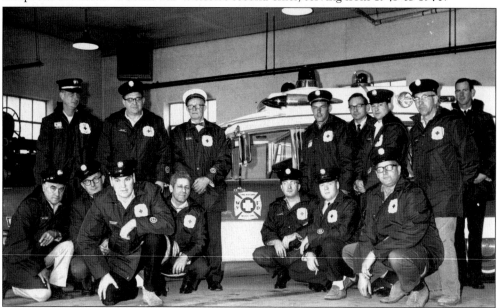

Gathered around the new ambulance in March 1968 are members of the Weston Volunteer Fire Department. Kneeling are, from left to right, John Guidera, Thomas Phillips, Richard Reifschneider, Tony Lagana, Paul Deysenroth, Gilbert Wood, and Joseph Spetly. Standing are, from left to right, Fred Moore, Robert Stein, John O'Brien, Robert Studwell, Gilbert Thirkield, Thomas Blythe, Edward Florian, and Franklin Moore.

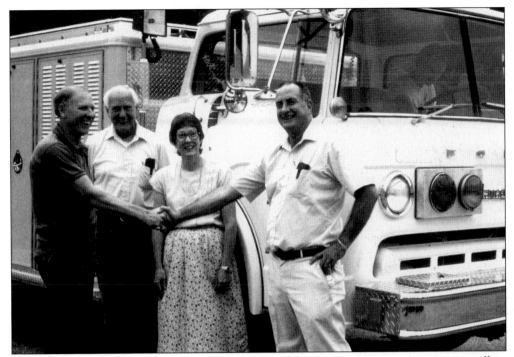

In 1985, Helen Speck, a first selectwoman, takes delivery on a new rescue pumper, still in service today. Chief Fred Moore shakes hands with a representative from the firm that outfitted it. Volunteer firefighter Charlie Porkorny joins the group and young John Porkorny, chief since 1996, sits in the driver's seat. Weston fire trucks have been yellow since the 1970s, when a federal study found yellow stood out better than red.

Fred Moore, who served from 1970 to 1996 as fire chief and continues as fire marshall, trained for two days with London firefighters in 1964. He was on vacation in England with his British wife, Ann.

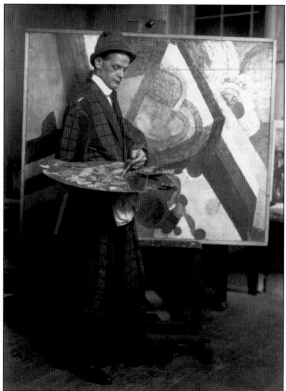

James H. Daugherty, known for his large modernist paintings, lived and worked at his Broad Street studio until his death in 1974. Today, his work is in many private collections and museums. Born in 1887, in Asheville, North Carolina, he came to Weston with his family by way of New York in 1923. Taken in New York, this glass-plate photograph was discovered recently by Daugherty's son, Charles, a distinguished muralist.

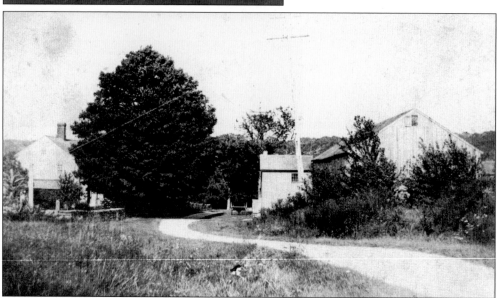

When Weston was more meadow and woodland than paved roads, artists and writers discovered this bucolic place. The verdant landscapes offered the budding Weston-Westport artists' colony inspiration and seclusion. Illustrator John Held Jr. produced wrought-iron pieces at his forge on Ladder Hill Road. Theater greats such as Lawrence Langer and Eva Le Gallienne moved to Weston in the 1920s. The town continues to attract celebrated actors, artists, writers, and musicians.

Novelist Sonia V. Daugherty works in the office of the home she shared with her artist husband, James, and son, Charles. Her out-of-print books for young adults can be found at the Weston Public Library. She collaborated with James, who also wrote and illustrated books. Together they provided a rich artistic life for Charles.

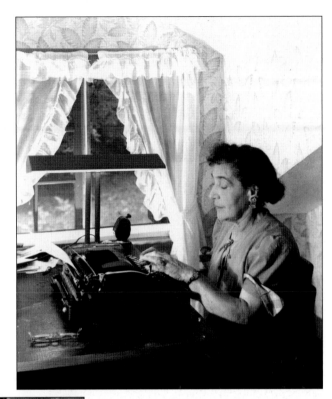

Charles M. Daugherty received his first art training in his father's studio. Later, he studied at Yale University and the Art Students League in New York with famous American artists. His family's history is woven into Weston's art community. He and his wife, Lisa Lindsay Daugherty, a sculptor, volunteered on many town arts projects. Their works displayed at town hall celebrate the early tradesmen and good government.

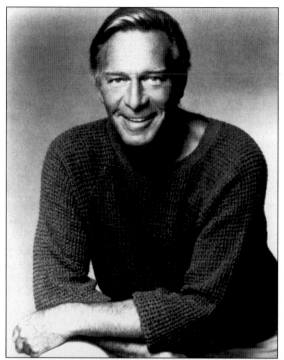

Award-winning actor Christopher Plummer has called Weston home for many years. The great-grandson of Canadian Prime Minister Sir John Abbott, Plummer has supported Weston's land preservation efforts. From his 1950 debut onward, he has been celebrated for numerous roles on stage and screen, but will probably be best remembered for his role as Captain Von Trapp in *The Sound of Music*.

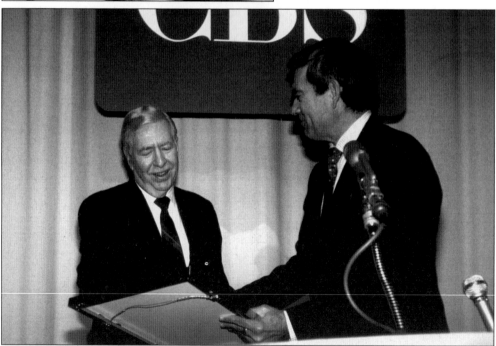

Douglas Edwards, left, accepts an award from former Easton resident, Dan Rather, at Edwards's retirement from CBS in 1972. Edwards lived in Weston from 1951 to 1965, at the height of his career. He served as president of the Weston Field Club and supported many local events. "Doug was the inventor of television news anchoring," said Dan Rather. "He also set many of the standards that still apply."

118

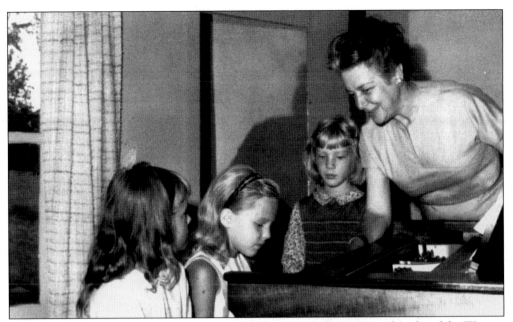

Susan Neilly is at the keyboard, while teacher Constance Nash Coates, cofounder of the Weston Music Center and School of Performing Arts, looks on in 1964. Coates, a descendant of Bono Otto, surgeon general in George Washington's army, created a mini-Tanglewood at her home, 32 Steephill Road. Weston resident and artist Paul Cadmus and actress Tallulah Bankhead, a regular visitor to the area, frequented her salon. Today, Neilly is a director of the school.

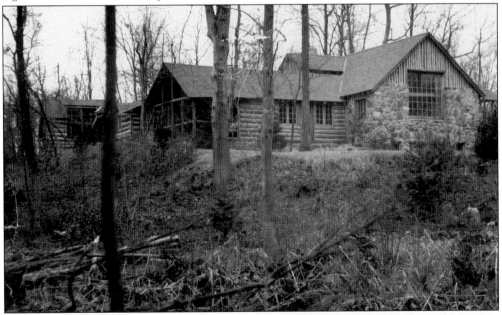

Built by artist Karl Godwin (1863–1962), this log cabin at 383 Newtown Turnpike became Weston Woods Studios soon after Morton Schindel bought it in 1953. Beams hewn from ancient chestnuts and fieldstones gathered on the property are still in evidence in the original house. As his business of picture books on film grew, Schindel expanded. Today, it is the Weston Woods Institute.

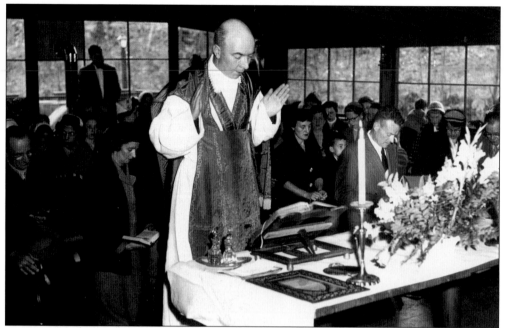

Fr. Joseph Cleary of Sacred Heart Roman Catholic Church in Georgetown celebrates Mass on Palm Sunday, 1954, at Cobb's Mill Inn. Although the regimental chaplain of General Lafayette's staff celebrated the first Mass in Weston, it took almost 200 years for the first Catholic parish to form. On Christmas Eve, 1958, St. Francis Church opened with Mass at midnight.

After teaching in Weston, Helen Budd Mason (1904–2003) joined the U.S. Army and was decorated with the American Campaign Medal and World War II Victory Medal. After the war, she moved to New York and began a career as a writer and publicist. Later, when she married, she returned to Weston.

Fred Moore, uncle of fire marshall Fred Moore, was one of two residents killed in World War I. The other was Kenneth Miller. Moore was a sharpshooter who volunteered to form a special detail of scouts and snipers in 1918. He is seen here c. 1912.

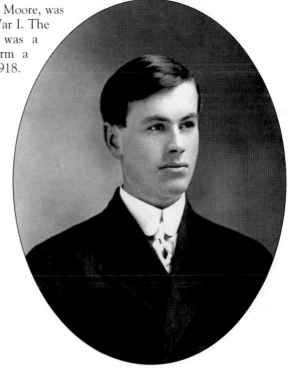

Fred Moore, left, joined the U.S. Army in 1913 at age 17 and rose to sergeant. He and another volunteer took out five machine nests on September 26, 1918, the first day of the Meuse-Argonne offensive, a decisive point in the Franco-American offensive. Moore never returned. Two other Moore brothers, Miner and Miller, fought in World War I and died young, succumbing to the aftermath of mustard gas attacks.

Archaeological digs at the Nature Conservancy's Devil's Den Preserve produced evidence that early Native Americans inhabited parts of the den, in particular a large natural rock shelter. Although the area has been disturbed over the years by artifact hunters, archaeologists were able to find ample proof that it was used as shelter from late summer through fall.

Weston's Devil's Den was preserved by Katherine Ordway (1899–1979) through a 1966 gift to the Nature Conservancy. She donated the land in memory of her father, Lucius P. Ordway. As heiress of the 3M fortune, Katherine Ordway, who lived on Goodhill Road, discovered her passion for preservation in Weston, then went on to make monumental contributions to national conservation efforts.

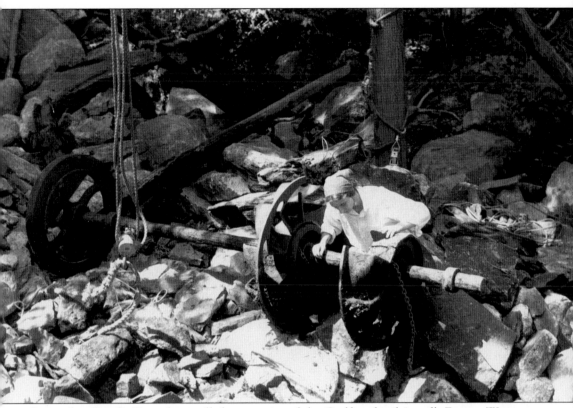

Located in Devil's Den, this is all that remains of the Godfrey family's mill. Former Weston Historical Society secretary Edna Lutz examines the mill's turbine. An 1867 map shows the sawmill, but it probably also served farmers on Godfrey and Georgetown Roads as a gristmill.

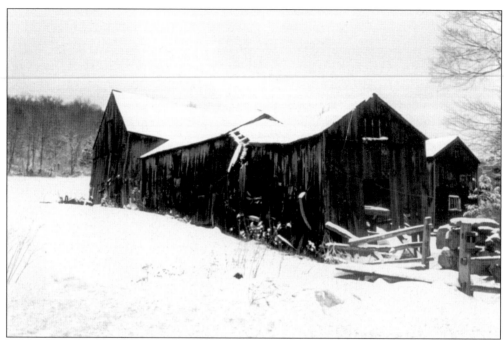

Snow covers the barns of Leon Lachat on West Godfrey Road in 1975. Lachat's family farmed there since 1933. The property is now owned by the Nature Conservancy and the town of Weston, which purchased it after a town referendum.

Small barns like this are remnants of the past. In the 1880s, this was a blacksmith shop on Goodhill Road. Around town today, there are still a few outbuildings, well houses, and root cellars.

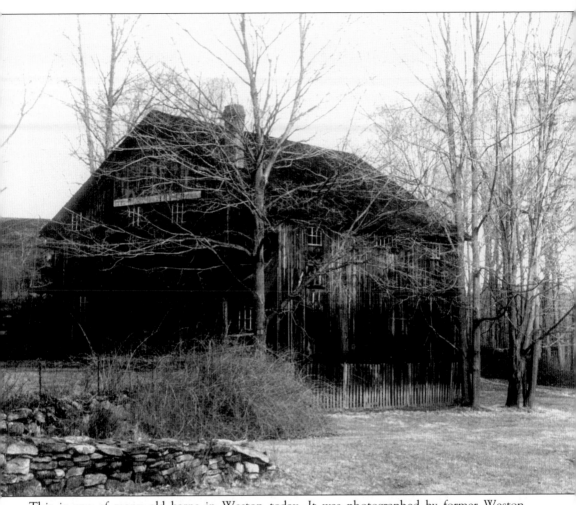

This is one of many old barns in Weston today. It was photographed by former Weston Historical Society president Roger Core.

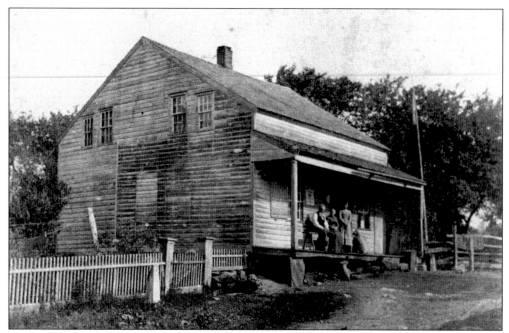

In the 1970s, the town began acquiring open space, and one of its first purchases was the 45-acre Scribner property at the corner of Routes 57 and 53. It became Bisceglie-Scribner Park in 1978. In October 1984, the town accepted the old post office, pictured here, from Lloyd Scribner. With private funds, the building was moved and restored.

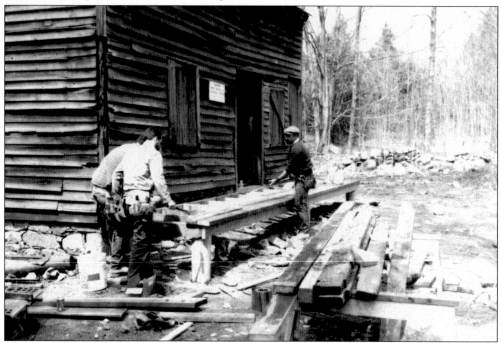

Gary Samuelson, right, with a crew, restored the old post office and general store in the summer of 1985. Built in 1780 as a small cabin, it was added to and became a post office and store in 1818. The post office was in service until 1910.

The 1980s were a time of change in Weston. In 1987, the Norfield Congregational Church restored its lofty spire. Over time, weather had weakened the tower timbers, causing the spire to lean toward the roof of the sanctuary.

By the 1980s, the centrally located old Onion Barn on Weston Road had become the town's bulletin board. The Kiwanis Club, which rallies through the years to maintain it, was installing a new roof when this photograph was taken.

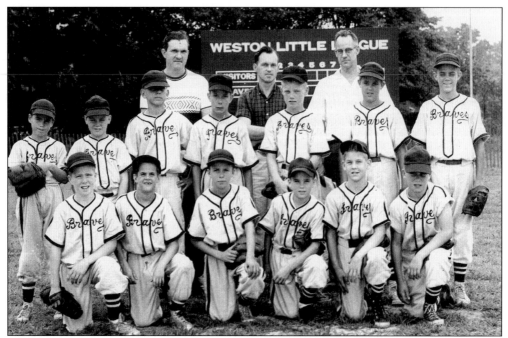

The summer of 1956 was an excellent first season for the Weston Little League. The Weston Braves beat the Wilton Hawks in a best-of-three series that saw evenly matched play by both teams. Bob McCarthy was Weston's winning pitcher. The coach was Jack McCarthy.

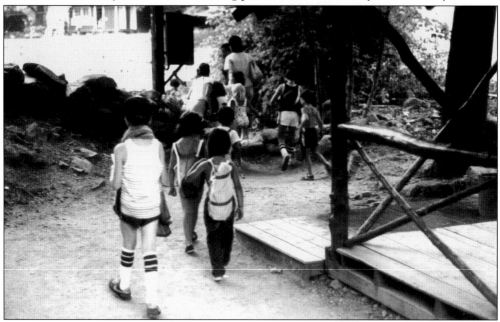

Children at Singing Oaks Day Camp on Newtown Turnpike follow their counselor along a trail in the early 1980s. Camps for children and adults were plentiful at one time. Only one survives today, the Girl Scout's Camp Aspetuck, in operation since 1939. Like Singing Oaks, which closed in 1987 to build a subdivision, Weston's camps went the way of farms as residential development increased.